The 1000 Journals Project

100

JOURNA

PROJECT

BY SOMEGUY FOREWORD BY KEVIN KELLY

CHRONICLE BOOKS
San Francisco

Library of Congress Cataloging-in-Publication Data available.

ISBN-10: 0-8118-5856-1
ISBN-13: 978-0-8118-5856-4

Manufactured in China.

Designed by **Altitude**

10 9 8 7 6 5 4 3 2

Chronicle Books LLC
680 Second Street
San Francisco, California 94107
www.chroniclebooks.com

Cover artwork by **Linda Zacks**

This book is dedicated to everyone
who's ever said, "I'm not creative."

And most of all
for you,
Jen !!!

♡ LE

Foreword

Some folks worry that the digitization of our daily lives will make us disembodied ghosts. They fear that we'll become fat lumps of tissue plugged into some giant machine, and that our souls and minds will migrate to cyberspace, where our egos will drift as mere whiffs of electrons. We'll work, play, shop, and live online, and the real world—the physical world and all its pleasures—will rot.

Nothing could be further from the truth. In fact, technology is steadily moving us toward a future in which intangible bits of digital information are more and more embedded into our very physical world, and the physical world is pervaded by ubiquitous digital bits. The world of atoms (bodies) and the world of bits (minds) are converging. Soon, every object made will have a tiny bit of mind in it, and our intellectual lives will intersect with almost everything made.

A prime example of this confluence of mind and body is Someguy's 1000 Journals Project.

The project takes three vast networks and weaves them together. It begins with the oldest peer-to-peer network we have—face-to-face exchanges—and then adds our second-oldest network—the postal system—which is cheap, truly global, and able to move tangible, very physical artifacts, like books, to anywhere in the world. Someguy leaves blank journals in random places, or mails them to strangers, with instructions to create personal pages inside them and pass them on to other strangers. That's a great recipe for wonderful serendipity. But on top of these two robust networks of one thousand moving journals, Someguy added the new global network of the Web, which is able to track and enliven the digital ghosts of the traveling books.

These handcrafted works of art now have both a body and a mind. They are deeply rooted in the sensual materials used to create them: paper, ink, found objects. But they also live the life of a mind as they are queued, monitored, and set loose into the collective consciousness.

In a very real way, these books are written and drawn by "us"—the hive mind—rather than one person. No individual artist chooses who works on a book; rather, the choice emerges out of the crowd. But unlike previous collective art projects, with this new online network, we can watch the hive mind at work. We can watch the collective thinking out loud and assembling the sequence within a book and among books. We can watch it remember and watch it forget, as it abandons thoughts and books and then later revisits them.

It's this newfound ability for the project to watch itself that gives it a tiny glimmer of self-consciousness. From our perch in front of the screen, we can watch ourselves say something as a collective, and we can see half-formed thoughts begin to move through the network as they are assembled, page by page, into a lasting work of art.

If all the finished journals came to rest in one place, it would not contain the full project. Only the interactive Web can do that. Part of the project is the anticipation, worry, and joy of tracking the books on their journeys. Part of it is the mystery of when a book goes dark. And part of it is simply the energy of a book in motion. Mostly, the project resides in watching, and the self-reflection that the Web interface enables. All this will be missing when you gaze upon the bound pages of a journal.

Then what about this book you're holding in your hands? It is the thousand-and-first journal, a compilation extracted from the other books, a journal derived from watching the roaming, growing trail of pages. It acts like a self-reflection of the project, a thought about the other thoughts, a meta-book about books. It employs the same associative logic between its pages as the thousand other journals, but this thousand-and-first journal is the first completely finished book in the series. As you will witness in the pages that follow, its glorious combination of diary, visual wit, intense expression, and brilliant cleverness reflect the stunning power of the full set of journals.

In a curious way, this compilation may spark many of the unfinished books to continue on their journey. It may remind those who have left their gifted book under their bed to move it on, or it may remind friends of friends to finish their pages. Who can remain inert after seeing this book of wonders, or hearing of this project?

It is the power of participation unleashed by the 1000 Journals Project that is its lasting achievement. Many more than the thousands who drew or wrote in the books were able to participate as they monitored and tracked its progress. Their engagement is an act of creation as powerful as pasting a note onto a page. And this participation will widen as the project expands into 1001, 1002, 1003 Journals. Following the same path, tens of thousands more folks, no more expert than Someguy, will independently launch their own blank books into the wild, to be animated by the hive mind and touched by the hands of the world as they roam the postal and social networks. For it is the high-technology networks that disperse and guide these romantic tactile books.

Someday journals will have chips in them, making their location clearer, and the task of tracking them easier. Someday the idea of 1000 Journals will seem so obvious. But you don't have to wait for someday, because within the covers of this book are thoughts from the global hive mind of today.

It's a grand, wonderful, brilliant, and satisfying experiment, and you are part of it.

—Kevin Kelly

Introduction

I've always been fascinated with graffiti, whether scrawled on bathroom walls or carved into park benches—anonymous conversations and arguments held in public spaces for the world to see.

With raw and spontaneous scribblings, the walls become a forum of sorts, a collection of opinions about drugs, politics, sex, war, racism, and a healthy dose of drunken poetry.

Translating that energy into a collaborative art project became an obsession of mine. I remember walking home from work one day, running through ideas in my head. It finally occurred to me that a journal was the perfect medium to engage, and, unlike a wall, it could travel around the world. On June 17, 2000, a typically cool San Francisco summer day, the 1000 Journals Project was born.

In August of that year, I began distributing blank journals around San Francisco. I left them in bar bathrooms, at cafés, and on the bus, and gave them to friends and strangers. Each journal contained instructions inviting participants to contribute something to the journal, and then to pass it along to someone else. There were no rules, and the only limitations were those that participants set for themselves. The process was a mix of a message in a bottle and the "exquisite corpse" technique used by the surrealists. The technique is based on an old parlor game and requires that each participant write or draw on a sheet of paper, fold it to conceal their work, then pass it to the next participant. The end result is a product of the group's collective consciousness.

When I started this project, I had no idea if the journals would ever return. I suppose that's one of the reasons there are a thousand of them (that, and it seemed like such an absurd number, I had to do it). Like baby turtles moving across the sand in a mad dash for the ocean, not all of them would make it, I knew. With each journal I released, there came a feeling of anxiety, a fear that I'd never see it again. This was always followed by hope, though, as I imagined the potential each journal had, the lives it might touch, and the journey it would take. Some journals would find their way into closets or storage boxes, while others would go on tour with bands, rack up frequent-flier miles, or end up in the middle of a war.

Each journal is roughly the size of this book, with a cover design mounted on the front and back. It was important for the journals to be something people would want to pick up, but not so precious that they'd never let them go (it remains to be seen how well this second goal was accomplished). Each design appeared on ten of the journals, for a total of one hundred unique covers. I designed a few, but most were contributed by well-known and emerging artists from around the world—including Amy Franceschini of Futurefarmers, renowned rock poster artist Mark Arminski, illustrator Gary Baseman, and digital guru Joshua Davis, to name just a few.

Word of the 1000 Journals Project spread, and emails poured in asking for journals. I started mailing them to folks, spending my weekends toting grocery bags full of journals to the post office. As people began to send in scans of their entries, I came to realize the full potential of the project. The pages were filled with amazing artwork, secret confessions, political rants, and everything in between. One person shared his experiences of growing up in Bahrain (#757), while another wrote a letter to a loved one (#001). Someone cut up a map of Africa and rearranged the continent (#438); someone else used spray paint stencils to redesign a journal cover (#884). Inspirational advice, personal sorrow, anger, love, and pure creativity poured into the journals and were shared with strangers.

What has happened to the journals is a story itself. They've come to rest in hostels, cafés, and law offices; they've been lost and found, forgotten and remembered. They've been the subject of treasure hunts (#354), brought to remote mountaintops (#323), abandoned at airports (#001), left in the lost-and-found (#300), and stolen at gunpoint (#949). In journal #587, someone wrote a heartfelt apology and then sent the journal to the friend they had wronged. Unfortunately, the apology wasn't accepted.

There is no set completion date for the project, and it may very well go on indefinitely as the journals continue to hop the globe, making their way in and out of individual lives. What you see here is just a small sampling of the thousands of contributions from more than forty countries and every U.S. state. I imagine that twenty years from now, there will still be journals floating around, trying to make their way back home.

Based on flux and faith, the 1000 Journals Project is an experiment where the journals themselves are a museum and every participant is an artist.

–Someguy
project creator

This is an experiment,
and you are part of it.

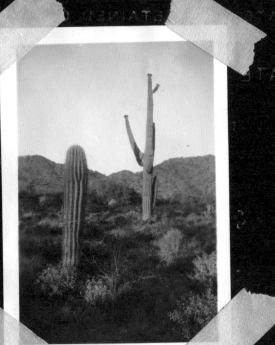

UT WHERE

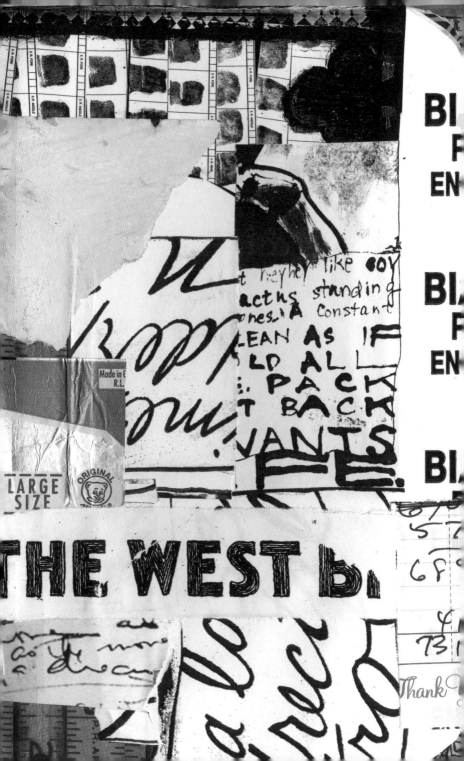

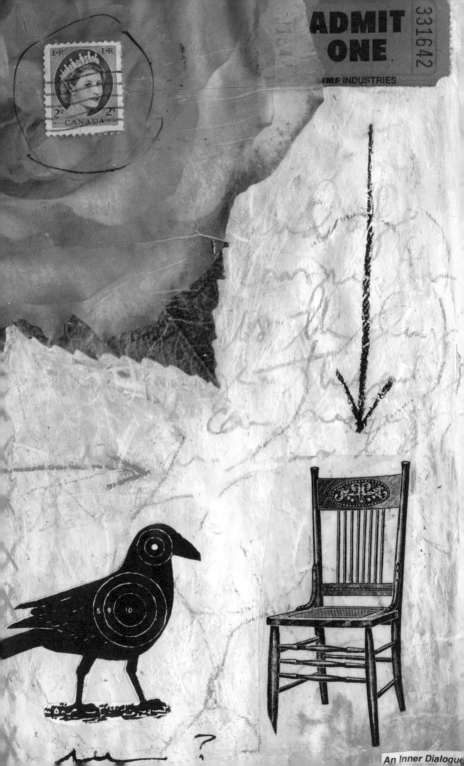

ADMIT ONE

331642

IMF INDUSTRIES

CANADA 2¢

?

An Inner Dialogue

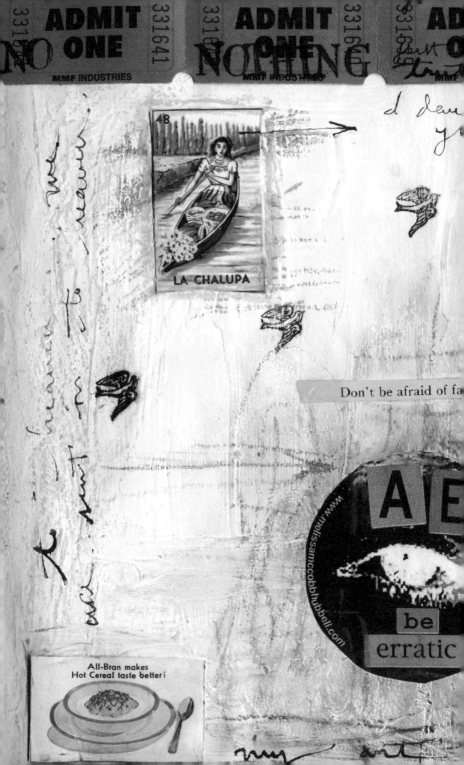

4B

LA CHALUPA

Don't be afraid of fa

All-Bran makes
Hot Cereal taste better!

A E

be
erratic

www.melissamccobbhubbell.com

Journal 493

Ottawa, Canada

I was at Ravinia (a great summer festival of music—classical, jazz, pop, Latin, etc.) and I was watching Oscar Peterson play some mean jazz piano. This real artsy couple that was sitting next to me on the grass was poring over a book—I was trying not to watch them, but they were interesting, so I was writing about them in my own journal. The guy must've noticed, because as I was leaving he handed me #493.

DO YOU THINK THERE WAS LIFE BEFORE PAGE SIXTY?

WE CAN NOT KNOW THIS FOR SURE...

BUT SOME SAY THAT YOU CAN SEE THE PAST...

... AS WELL AS THE FUTURE THROUGH A LITTLE HOLE IN OUR TIME...

THERE WAS A TIME OF VAN-GOGH-ALIKE FOAM THAT COVERED THE WORLD...

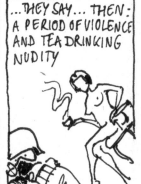

...THEY SAY... THEN: A PERIOD OF VIOLENCE AND TEA DRINKING NUDITY

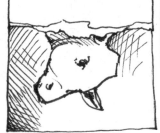

A GREAT COW THAT LOOKS OVER THE WORLD FROM THE BLUE OF THE HEAVENS...

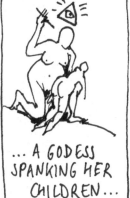

... A GODESS SPANKING HER CHILDREN...

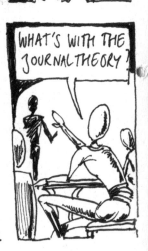

WHAT'S WITH THE JOURNAL THEORY?

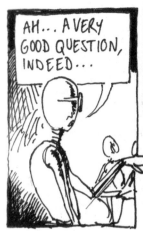

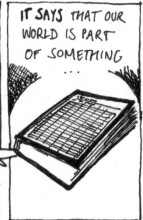

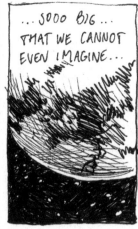

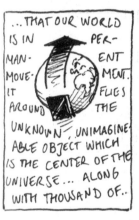

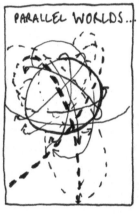

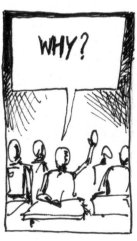

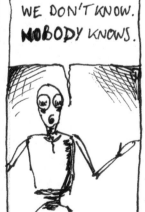

61

Protogue:

Born 1971 Jackson heights Queens, NYC

What is now all blurredes and soon to be
memories will
records of my life. ...d graphic

Everything past, present... ...
be dripped onto everyth... ...
presented for thewill now

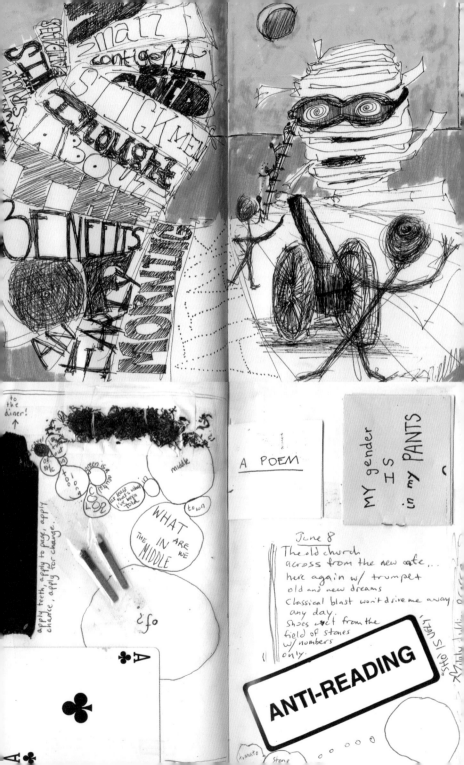

If I can't do dressage
I will die...

Do you miss me?

But I can't escape from the feeling
As I try to leave the memory behind

I miss you...

Slowly drowning...

Got to get you out of my mind

LOVE

tears

go to bed early so I can dream of you

INNOCENS

think of me...?

LOVE

IS FIRE BORN WITHIN EACH HEART OR SPARKED BY EXPERIENCE?

CREATION FLOWS FROM DEEP WITHIN. A RAGING TORRENT SO POWERFUL IT WILL DESTROY IF KEPT IN CHECK OR RESTRAINED IN ANY WAY.

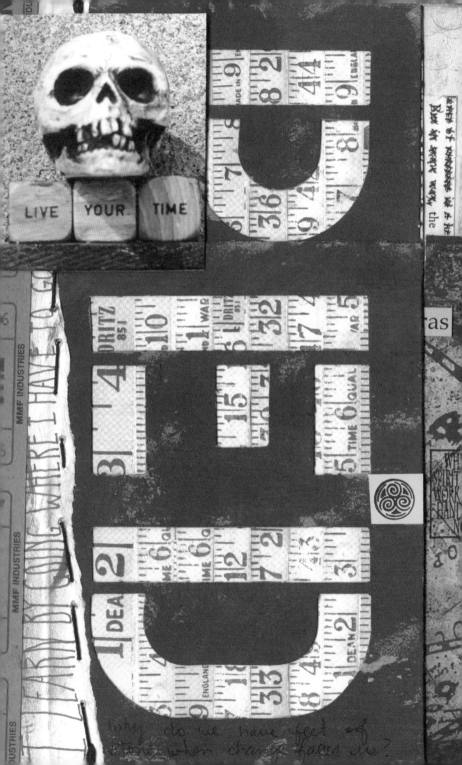

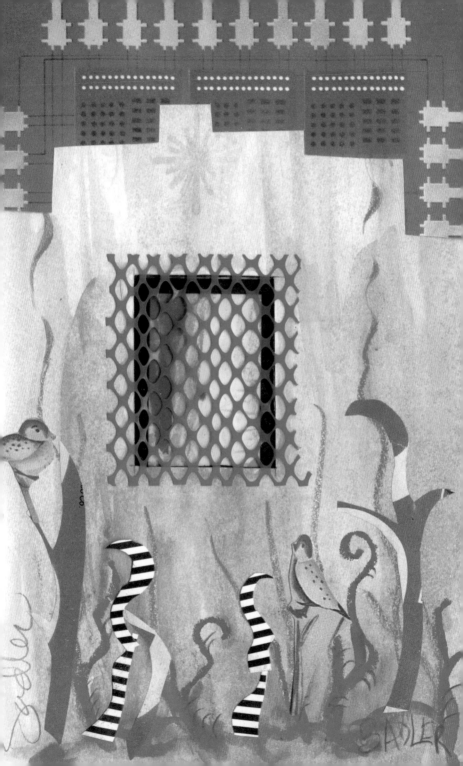

Journal 949

Savannah, Georgia

I'm sorry to everyone. I was robbed at gunpoint earlier today. They took my bag. In the bag was the journal. Many apologies.

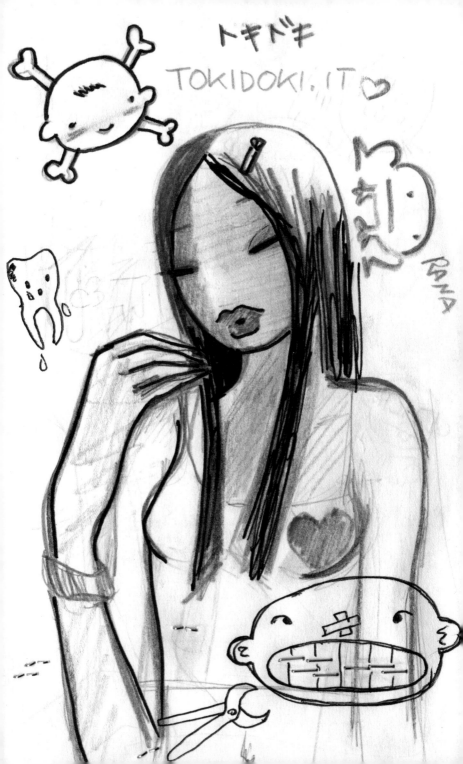

So we have this whole concept of time, and this whole philo. of keeping track of the seconds, minutes, hours days, years that go by... and is that all because we know its finite? One day it's all going to end. So did you ever realize <u>we</u> decide how time is calculated ...and if we didn't keep track of it wab it keep passing by? So I think the whole meaning of life (whoaa and we are only on the second page here) is wrapped up in this whole idea of time. We are so insignificant compared to other bodies and we age so rapidly in our calculation of time.

FOR EXAMPLE

if the history of the Earth (don't even get me started on the Universe) which we think is about 20,00 million years ago. Homo Sapiens have been in exsistanie for about 1,000,000 years

SEEMS LONG? YA! RIGHT

EVOLUTION OF LIFE IN 24 Hrs

HUMANS APPEAR AT 11:59 pm (all recorded human history ¼ sec before midnight!)

PLANTS INVADE

INSECTS & AMPHIBIANS

AGE OF REPTILES

AGE OF MAMMALS

FOSSILS APPEAR

FOSSILS PRESENT BUT RARE

Imagining the whole history of life on 24hr timescale means humans have been around for <u>less than a minute!</u>

So humans are tenuous beings.
Not the first.
Not the last.

But one absolute thing can be established... Place your hand on your heart and feel your life ticking by. One day it will stop.
TEMPUS FUGIT!

➔ SO LIVE, LOVE, FIND YOURSELF DON'T WASTE A SECOND!!!!

THEY SAID HERE,
DARLING DAUGHTER, HERE
IS THE SACRIFICE.
LOOKED DOWN INTO THE
DARK POOL OF RE...

Balancing Heaven & Earth between my eyes— I fall & stumble all the time.

EYE BADGE OF HANGING ON THERE

ENCLOSED

BATTLE WEARY
SELF-PORTRAIT

w/ the torn & tattered lip of neglect. a war-scar of my woman child

imagine

20th Cent[ury]

BOOKKEEPI[NG]

& ACCOUNTI[NG]

NINETEENTH EDITION

CARLSON • FORKNER •

my bitterness,

resentments, betrayals, fear, dis-
trust, condemnations, judgements,
abuse, victimization, finger-
pointing, insecurity,
racism, sexism, hate,
disease, remorse, —
persecution,
murder!
dictatorship, rejection, denial, repression, loss,
lack of connection and freedom, dishonesty,
devaluing of another, battle lines. All my
self abuse & neglect support the dehuman-
izing stance of George & his cronies.

CHAPTERS 1 TO

B 51

Nan

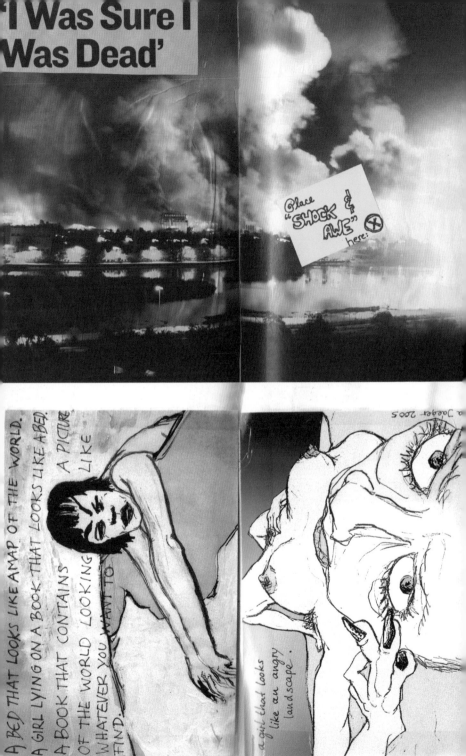

'I Was Sure I Was Dead'

Place "SHOCK & AWE" here: ☒

J. Jaeger 2005

A BED THAT LOOKS LIKE A MAP OF THE WORLD.
A GIRL LYING ON A BOOK THAT LOOKS LIKE A BED.
A BOOK THAT CONTAINS A PICTURE
OF THE WORLD LOOKING LIKE
WHATEVER YOU WANT TO
FIND.

a girl that looks
like an angry
landscape.

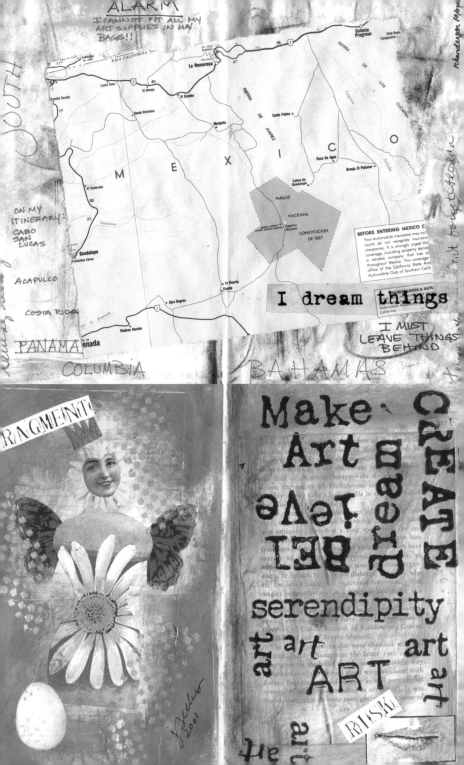

ALARM

I CANNOT FIT ALL MY
ART SUPPLIES IN MY
BAGS!!

SOUTH

ON MY
ITINERARY:
CABO
SAN
LUCAS

ACAPULCO

COSTA RICA

PANAMA

COLUMBIA

BAHAMAS

I dream things

I MUST
LEAVE THINGS
BEHIND

BEFORE ENTERING MEXICO C

Make
Art
dream
BE!
serendipity
art ART art
CREATE
believe

RISK

FRAGMENT

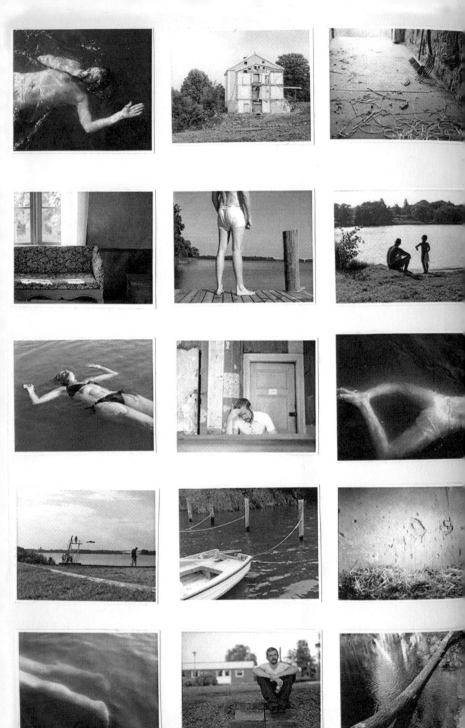

 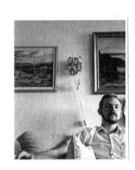

URG

LETTING GO

FIND SOME INSPIRATION & JUST PLAN TO THE NEAREST OUTLET PLUG IN & LET IT FLOW FORGET INHIBITIONS & FEARS SOUNDS TO GOOD TO BE TRUE, RIGHT?

SLOW IT DOWN. LET GO & REWRITE BAD MEMORIES. LIFE CLEARLY IS DIFFERENT FROM NOW ON.

IT'LL ALL SURE MAKE SENSE SOON...

Smile

CREATING A SPACE IN A WORLD WHERE EVERYTHING SEEMS TO GET SMALLER AT THE END OF EACH DAY. AND YOU'RE LEFT TO WONDER... WHAT'S REALLY

MINE?

I'LL SEE IT ALL SOON. I HOPE. WANNA JOIN ME?

SOMETIMES YOU JUST FEEL LIKE

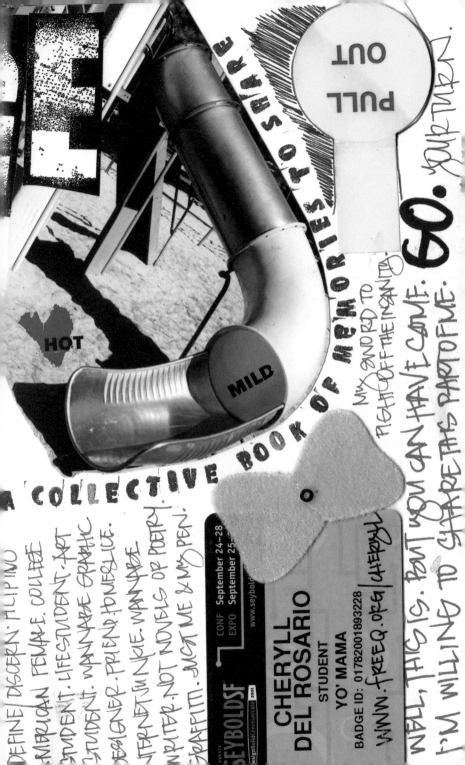

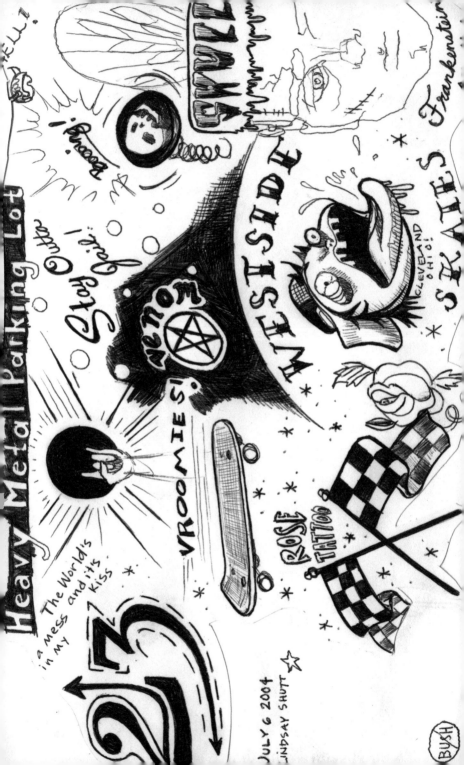

Journal 300

Anaheim, California

I found this journal at the restaurant I work at in a hotel. I just started working there maybe a month ago. Today I was collecting the stuff people had left behind to take it to lost and found. I came across this journal and read the cover. Someone told me it had been sitting there for the last two months, so instead of taking it to lost and found, I took it home with me. I wrote a little something in it and tomorrow I will send it on its way!!

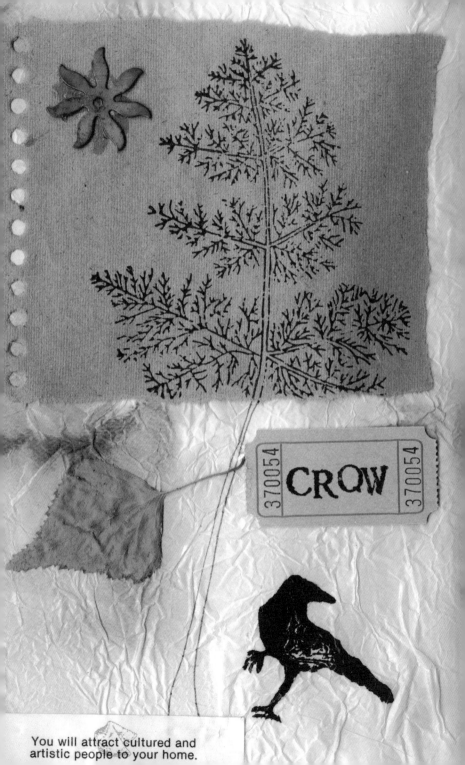

370054 CRQW 370054

You will attract cultured and
artistic people to your home.

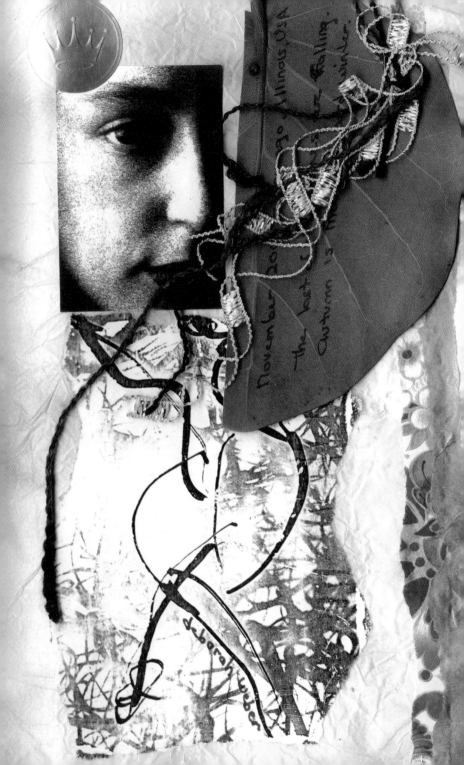

November 20 Chicago, Illinois, USA

The last leaves are falling.
Autumn is the reminder of winter...

deborah weber

Pure ...
open rage
(only feeling in the world)

die Katze tritt die Tr
krumm

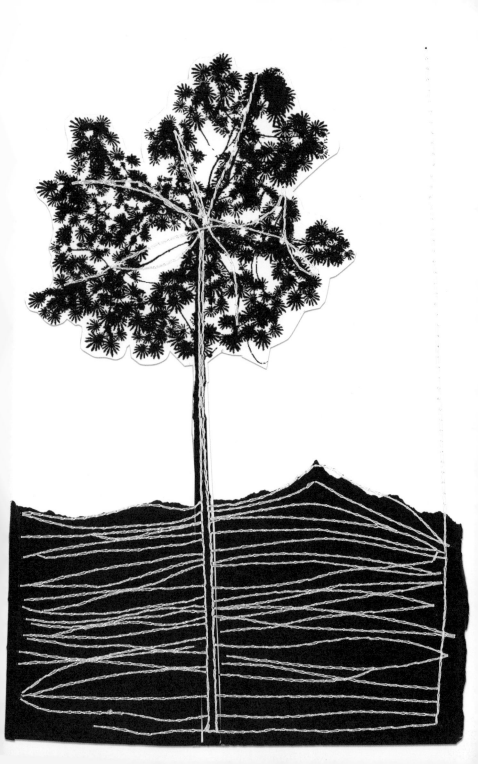

ARE GREATED BY ARMED GUARDS THEY ARE EVERYWHERE I LOOK

SOUTH
AMERICA

I don't feel like writing in this journal. It is too hot here. The people are so poor. The food is hot and smelly. We take a taxi out of town but instead of seeing the countryside all I see is poor.

old and sad children

CARTAGENA

the best part of South America was leaving. I got sick... too hot... too sad... too much

Its hot in COLUMBIA
FUN TOO
WE BUY FROM

SOUTH AMERICA
IS NOT SO
MANY BEGGARS
THE CHILDREN

move it along from...

SH810101

SEE REVERSE SIDE FOR OPENING INSTRUCTIONS

single-column

farewell my friends
peace, love, valerie roybal
albuquerque, new
mexico, october 2004

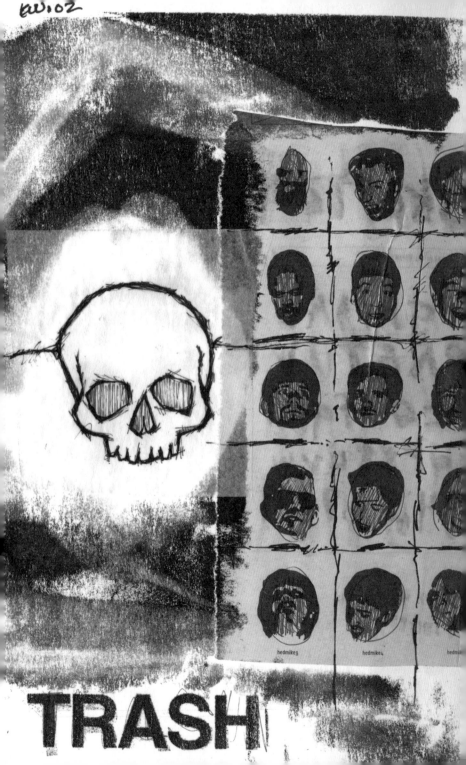

What is your idea of perfect happiness?

DRINKING WINE WITH IMPUNITY.
NO-WAIT! WEARING A NEW SUIT.
NO-WAIT! THE SECOND TIME I GO TO
BED WITH A NEW GIRL.
NO-WAIT! NO SUCH THING.
"CONSTANT CRAVING HAS ALWAYS BEEN."
PERFECT HAPPINESS IS DEATH.

Being at home with my wife, family, dogs, and friends.

To have no worries

Constant Travel, Friends Feeling-loved

EVERY GOOD THING I'VE EVER GAINED
FROM LIFE, I'VE HAD TO FIGHT FOR, I'VE HAD
TO PRY THEM FROM THE BLOODY, CLINGY
FINGERS OF LIFE.
 FORTUNATELY, LIFE IS A BITCH.
 TAKE THAT, BITCH.

What is your greatest fear? Losing my loved ones, lonlyness

Solitude. NO Friends
who believe in me.

...lying in a hospital bed
and having my friends and
loved ones pity me and feel
sorry for me

OR

having a child of mine disapp
and not know where they ar
or what happened to ther

Which living person do you most admire? my sisters GLEN CAMPBELL

my mom

What is the trait you most deplore in yourself? insecurity

Fear. Sarcasm. Keeping things to myself -

MY INSATIABLE LUST FOR NEW SEXUAL CONQUESTS.

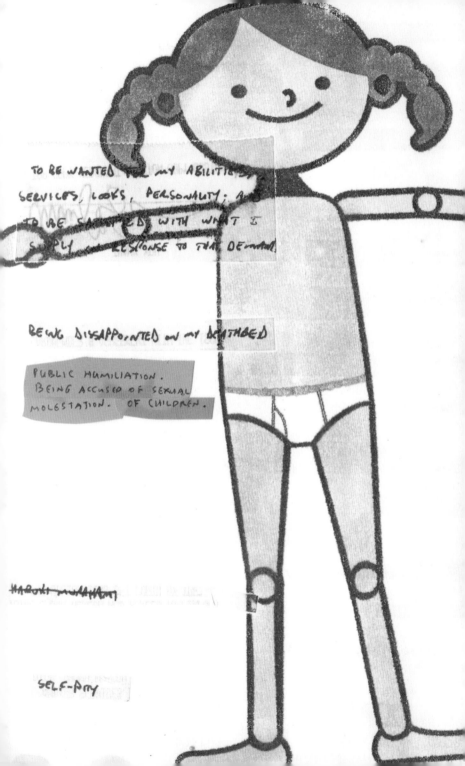

TO BE WANTED FOR MY ABILITIES,
SERVICES, LOOKS, PERSONALITY; AND
TO BE SATISFIED WITH WHAT I
SUPPLY IN RESPONSE TO THAT DEMAND

BEING DISAPPOINTED ON MY DEATHBED

PUBLIC HUMILIATION.
BEING ACCUSED OF SEXUAL
MOLESTATION. OF CHILDREN.

SELF-PITY

Journal 463

Minneapolis, Minnesota

A year ago at this time I was planning a trip to Amsterdam and France that turned out a hell of a lot differently than I expected.

It was on that trip that I planned to send #463 on its merry way across Europe; when I asked the proprietor of the English bookstore in Antibes to take it off my hands she refused. Maybe I didn't do a very good job of explaining what this project was all about or maybe she thought that some hardship or cost was involved. In any event, the journal made two transatlantic flights in my bag and was never set free in France as I had hoped.

Since then, my life has changed dramatically. After I returned from France I dumped my boyfriend, went all Independent Woman for a few months, met the absolute love of my life a few months after that, and married him eight weeks later. What does this have to do with the 1000 Journals Project, you ask. Like every journal I've ever had (and I've kept a written journal since I was twelve, circa 1988) I formed an attachment to the content that I couldn't quite bear to part with. In the pages of #463 is a description of every bottle of wine we drank, instructions on how to play the Forehead Game; it's a record of a time before I turned my life upside down. Of course I wanted to hold on to it for just a little bit longer than I should have.

Now, though, my life is changing again and for the better; I've finally reached a place where I am OK with letting that experience and the record of that experience go. I gave it to the woman who is subletting my apartment and I hope that she will also use it to document a time of change in her life.

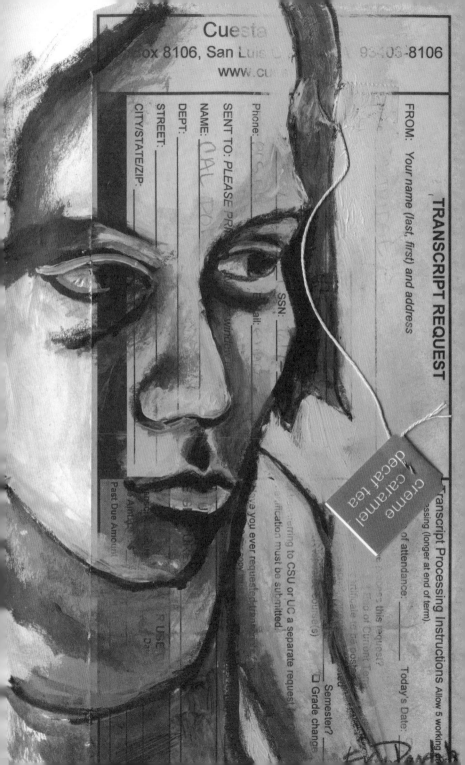

Who Are You? 4/9,10,03

My Name. Before I get to that point
let me tell you something about myself first
Today, today is a slow moving day for
Me. Feeling of confusion right has now
Sittled in. Not completely Depressed I feel
Is till have the energy to provide you
with some insight on who I am.
'At the age of 18 And A Senior in High School
I'm still Not Sure what I really want.
Catch me on a good day And maybe I'll Know.
But for right now No I don't. Spending my
time Listening to Bob Marley and getting

Stoned w/ my friends is what I look forward
to Every Day. Although changing the
Routine time to time wouldn't hurt.
Music of Choice? Pink Floyd – Janis Joplin
Anything that provides me with a
good Equanimity.
Its all I need. My excitement levels can
range from very High, Medium, to Low. Examp
High-New Drug. No worries – Medium-a Joint a new
 story

Have You Figured Out Who I am Yet?
I guess -
Its really not that important that you
could give a Fuck about my Likes or Dislikes
OR that I rambled on For a page just
so you could get that little insight.
The point is, I Am FRANCENE.
Still waiting For that Spectacular
moment of Revolution
to Hit!

While waiting I Draw This Picture.

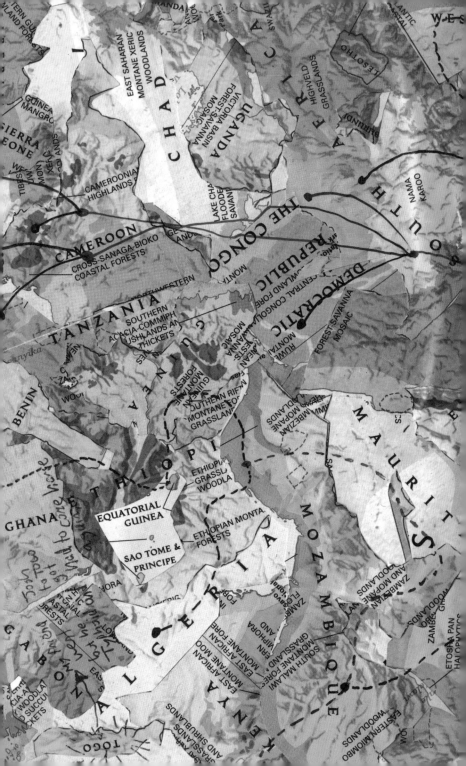

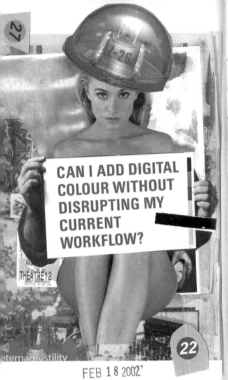

35

9

17

3

CAN I ADD DIGITAL COLOUR WITHOUT DISRUPTING MY CURRENT WORKFLOW?

THEATRE12

eternal hostility

22

23

YES!

30

39

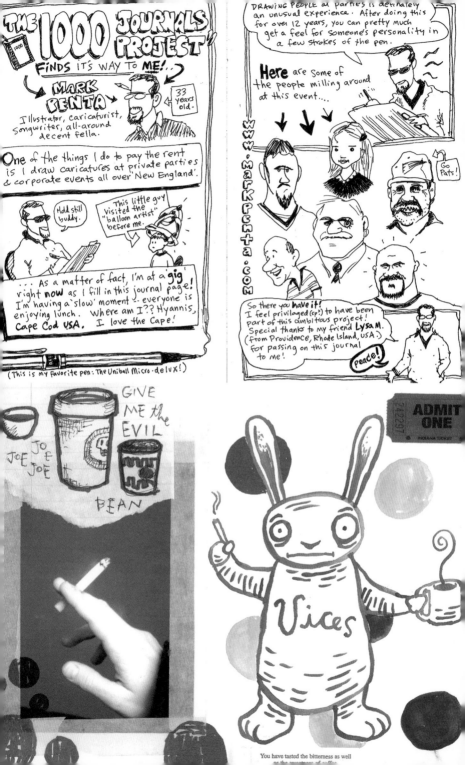

THE 1000 JOURNALS PROJECT FINDS ITS WAY TO ME!...

MARK PENTA

33 years old.

Illustrator, caricaturist, songwriter, all-around decent fella.

One of the things I do to pay the rent is I draw caricatures at private parties & corporate events all over 'New England'.

Hold still buddy.

This little guy visited the "balloon artist" before me.

... As a matter of fact, I'm at a gig right now as I fill in this journal page! I'm having a 'slow' moment - everyone is enjoying lunch. Where am I?? Hyannis, Cape Cod USA. I love the Cape!

(This is my favorite pen: The Uniball Micro-delux!)

DRAWING PEOPLE at parties is definitely an unusual experience. After doing this for over 12 years, you can pretty much get a feel for someone's personality in a few strokes of the pen.

Here are some of the people milling around at this event....

www.markpenta.com

Go Pats!

So there you have it! I feel privileged (sp?) to have been part of this ambitious project! Special thanks to my friend Lysa M. (from Providence, Rhode Island, USA.) for passing on this journal to me!

peace!

JOE JOE JOE

GIVE ME the EVIL BEAN

Vices

ADMIT ONE
INDIANA TICKET

You have tasted the bitterness as well as the sweetness of coffee

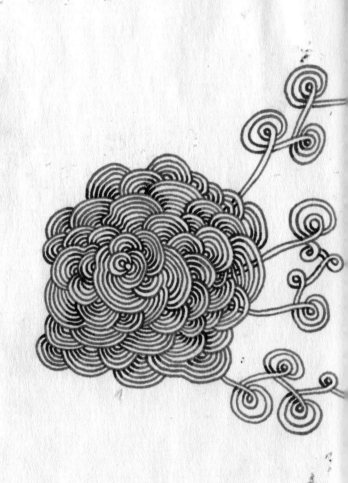

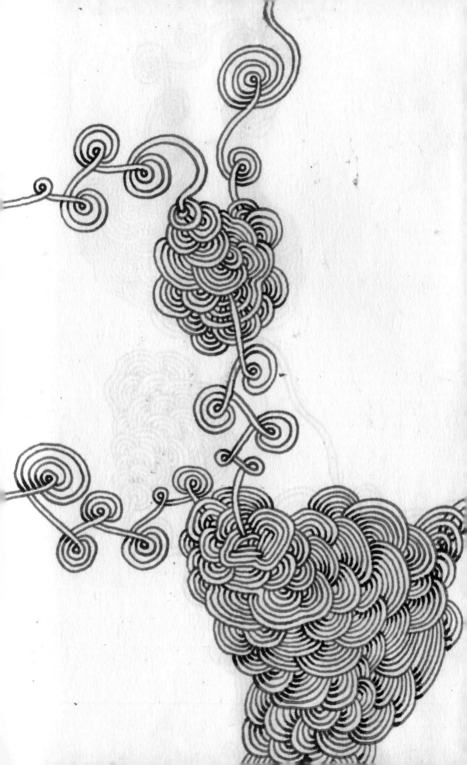

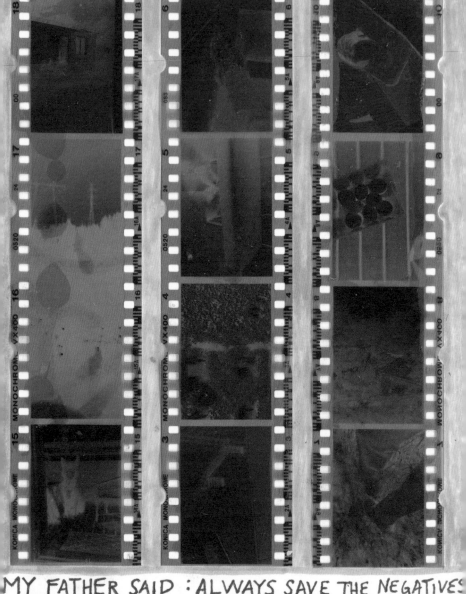

MY FATHER SAID : ALWAYS SAVE THE NEGATIVES

What a great start for a day

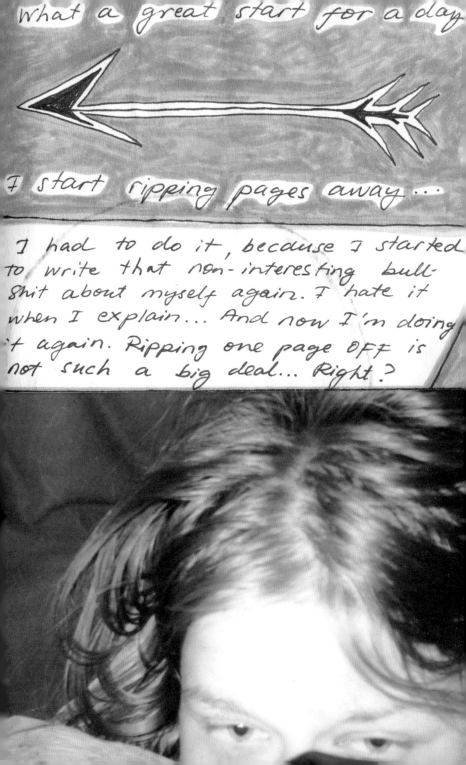

I start ripping pages away...

I had to do it, because I started to write that non-interesting bull- shit about myself again. I hate it when I explain... And now I'm doing it again. Ripping one page OFF is not such a big deal... Right?

it's like dropping your
most treasured item
out into the sea. from
this single action you
ruthlessly ~~bestow~~ upon
yourself the blame.
you regret everything
you didn't do.

and you think to
yourself that...

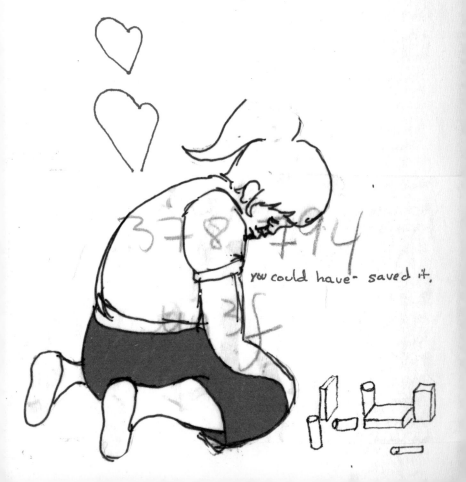

you could have- saved it.

Journal 049

Prague, Czech Republic

The journal was a huge hit. Everyone I ran into wanted to write in it. It was tough, but I held on to it until I got to Prague, in the Czech Republic. I left it on a scripture table that is on a vista of the modern city.

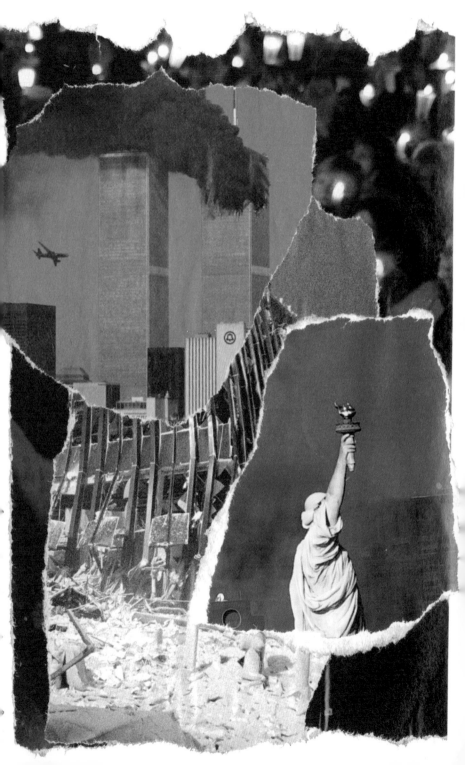

SEPTEMBER ELEVENTH THOUGHTS...

I was working when my daughter called saying, "Turn on the TV. Now." And then she told me what was happening. The World Trade Center, which I'd seen just two days earlier, gone now. The Pentagon, which I'd also seen on Sunday, also attacked. The imagery was somehow diluted by memories from disaster movies, almost identical to present reality. If anything, those big-screen images had more immediate impact than the apparent replays on our TV's small screen.

Still, throughout the day, the reality reached me through the surreal haze of shock & denial, and then was lost again in the bizarre bewilderment of the sheer horror that I still cannot fully accept or comprehend.

I do know that, today - the day after - I am thinking in more wary & less trusting/innocent terms than yesterday before the terrorists struck. I do not know the lasting effect, but I am saddened by it.

Aisling D'Art

ౙ ౙ ౙ ౙౙౙౙౙ ౙ ౙ ౙౙౙ ౙౙ

more "have to's" than "want to's" or "get to's." I am trying to shift the balance the other way, but it's a continuing challenge, and sometimes I feel like I'm fighting a LOSING BATTLE!

work is all about doing what other people want/need me to do. and home — which is much more joyous — is still about my family. Let's face it, the immediate needs of a 3 year old boy almost always trumped the needs of his 38 year old mom, especially when his needs are so specific, and my needs are so elusive. But my journal is a "WANT TO" and a "Get To" for me. It's a

Life right now...

IT IS WITH GREAT JOY AND HONOUR THAT I GET TO PRESENT TO YOU BOOK #930 OF 1,000 JOURNALS !!! MY NAME IS KEPI AND I SING FOR A BAND CALLED THE GROOVIE GHOULIES. WE ARE FRIENDS AND FANS OF S.BRITT, THE AMAZING ARTIST WHO DID THE COVER OF THIS JOURNAL. HE HAS DONE FIVE C.D. COVERS FOR US. PLUS TONS MORE... WE LOVE HIS ART! WE HAVE PLAYED ALL OVER THE U.S., CANADA, U.K., AND EUROPE. WE LOOK FORWARD TO VISITING JAPAN, AUSTRALIA, SOUTH AMERICA AND MORE IN THE NEAR FUTURE!

MORE S.britt ART! ↓

Hello! Bon Jour! Guten Tag!

VISIT OUR FANSITE AT GROOVIE-GHOULIES.COM SAY HI ON OUR MESSAGE BOARD

hello there!

MY CAT KAPY !! I IN A BELGIAN AIRPORT 4:00 A.M. ABOUT A YEAR AGO. TODAY IS JAN 11 2003

LAST NIGHT WE SAW A GIANT WORM

THIS JOURNAL BEGAN IT'S JOURNEY IN SACRAMENTO, CALIFORNIA .U.S.A.

Hello Hello Roach ♥ Je Suis Scampi.

GROOVIE GHOULIES

ROACH GHOULIE These Are My Band Mates Roach & Scampi... they Rock! We all like baked goods And being Sightseers on TouR !!!

SCAMPI GHOULIE SOMETHI I PAI ART. YOU C SEE A AT GoGro DoOR VISI S.brit At S.britt. THAN FOR READI THIS

S.britt ART!

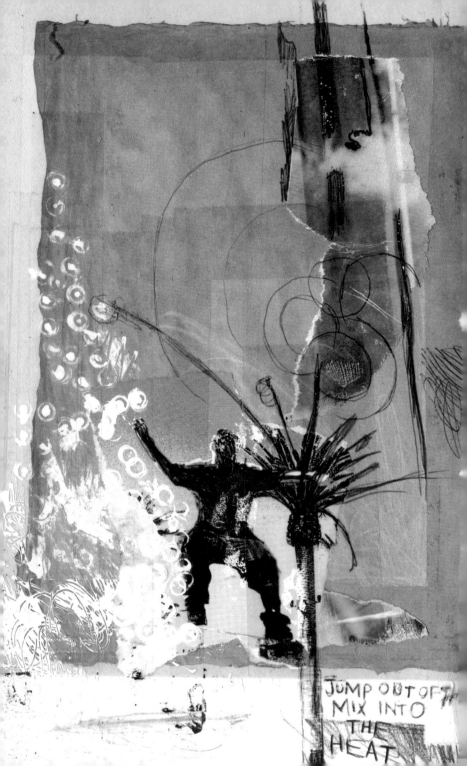

JUMP OUT OF
MIX INTO
THE
HEAT

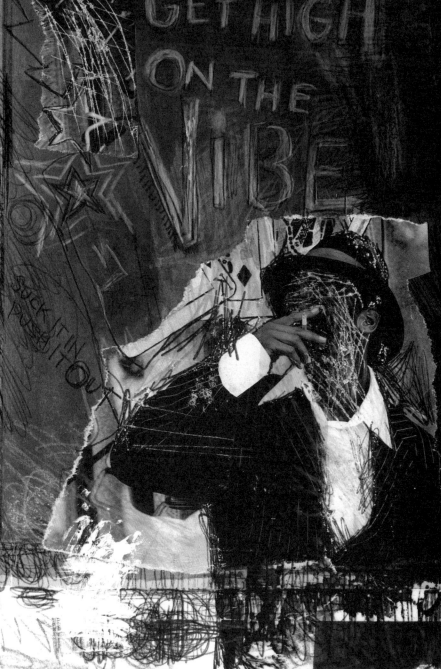

—Heav
Ho

— The Wife
Made
it.

He Used images from Popular culture
He Took Words from out of Context
He Moved To virginia,
Where He Met ALABAMA.

He had A daughter NAmed EMMA
who loved rAdio
He took off His shoes to TApdance
To the sound of the raiN.
He Ate Apples, And PAid TAxes
He Created MAelstromes,
And dipped His fingers in
Caustic SodA.

He Was DAD.

E
C

C

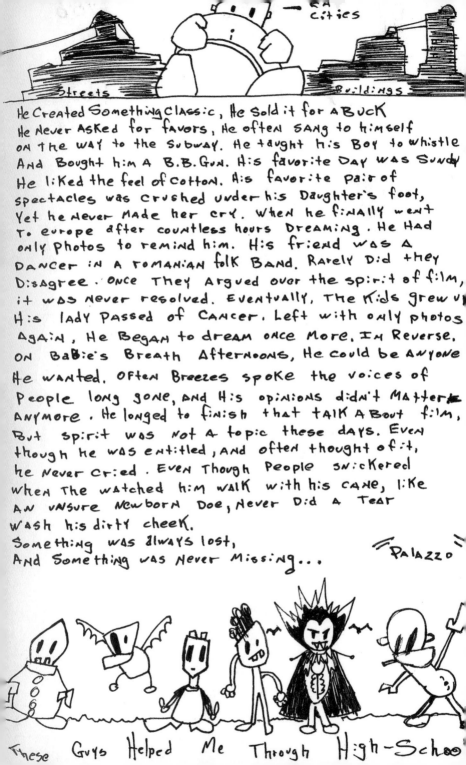

cities

streets Buildings

He Created Something Classic, He Sold it for A Buck
He Never Asked for favors, He often sang to himself
on the way to the Subway. He taught his Boy to whistle
And Bought him A B.B. Gun. His favorite Day was Sunday
He liked the feel of Cotton. His favorite pair of
spectacles was crushed under his Daughter's foot,
Yet he Never Made her cry. When he finally went
To europe after countless hours Dreaming. He Had
only photos to remind him. His friend was A
Dancer in A romanian folk Band. Rarely Did they
Disagree. Once They Argued over the spirit of film,
it was Never resolved. Eventually, The Kids grew up
His lady Passed of Cancer. Left with only photos
Again, He Began to dream once More. In Reverse.
On Babie's Breath Afternoons, He could be Anyone
He wanted. Often Breezes spoke the voices of
people long gone, And His opinions didn't Matter
Anymore. He longed to finish that talk About film,
But spirit was Not A topic these days. Even
though he was entitled, And often thought of it,
he Never cried. Even Though people snickered
when The watched him walk with his cane, like
An unsure Newborn Doe, Never Did A Tear
Wash his dirty cheek.
Something was always lost,
And Something was Never Missing... "Palazzo"

These Guys Helped Me Through High-School

Journal 667

Strange forms of collaboration, these books. Interesting interactions created. I can promise I never would have spoken to "Razzzberry Swirl," a.k.a. Marguerite, without the book as a medium. No matter how surreal the interaction, I can say that there is something fantastic about being the catalyst for that interaction (Someguy creates 1,000 journals from thin air, sends them out to the world, and they run around wreaking havoc, getting lost at train stations, running with the bulls in Pamplona, sailing around the world, etc. You have created something from nothing).

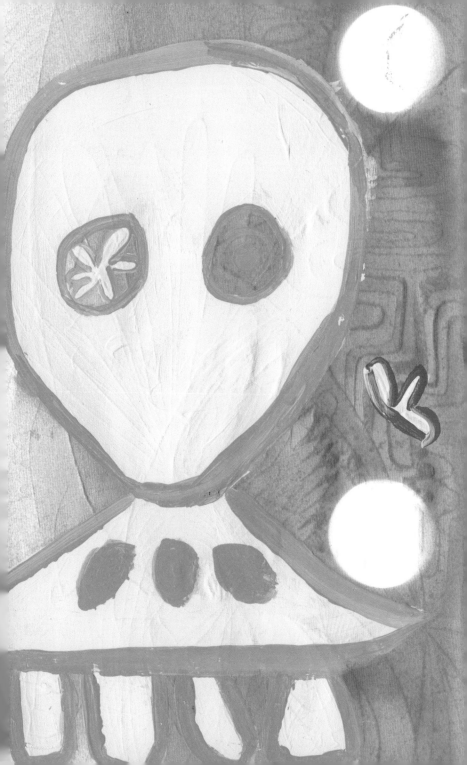

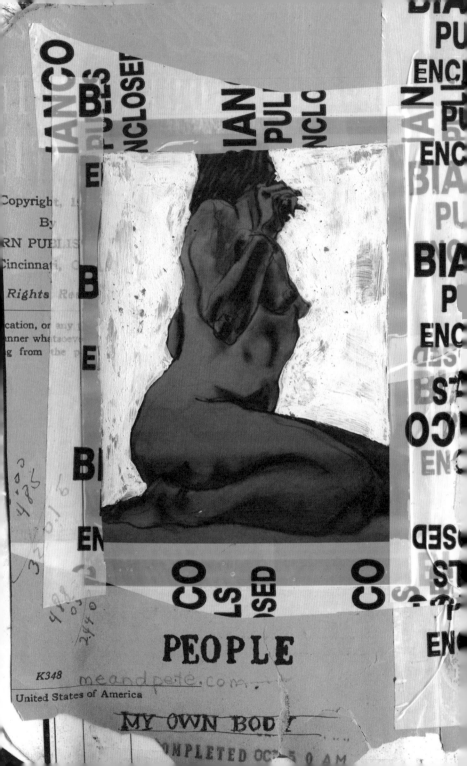

PEOPLE

K348 meandpete.com

MY OWN BODY

OMPLETED OC 5 0 AM

GEORGE HAS STEPPED
INTO THE SHADOW
CAST UPON THIS
PLANET. IT STRETCHES
IN THE LOW
LIGHT
OF WINTER

FROM
WHERE
I SIT,

AWAYAWAY

shadows, clear & defined.

COMPLETED OCT 5 0 A.M VOTE

IN DÜSSELDORF / GERMANY DOGS
HAVE TO WEAR A

MAULKORB, BECAUSE

PEOPLE ARE NOT ABLE TO LIVE IN
PEACE & LOVE WITH THEM, SO THEY BITE
THERESIA KOPPERS

Alcohol Prep
Isopropyl Alcohol, 70% V/v
Sterile
2 Ply Medium

For external use

STAT

CRITICAL CARE
UNIT

North Wing
d Floor Waiting Room
lease call unit from
aiting room before
visiting

VISITORS
2 per patient
e limit at the discretion
of the nursing staff.
One spokesperson per
family.

Phone:

Bioethics

a discipline dealing
with the ethical
implications of
biological research
and applications,
especially in
medicine.

BIOHAZAR

THE NAKED FLASH OF S

ALITY AND
RESHNESS
ARANTEED

QUALITY CHICKS

oh

my

urn

TEEN TARA
SUPERIOR QUALITY
★ ★ ★
PRICE INDO Reg 0 0 6
ALL INDIA MATCH SYNDICATE LTD
CHANDRA MATCH WORKS, THIRUTHUNGAL

27

special protection

EL CORAZON

ESPAÑA

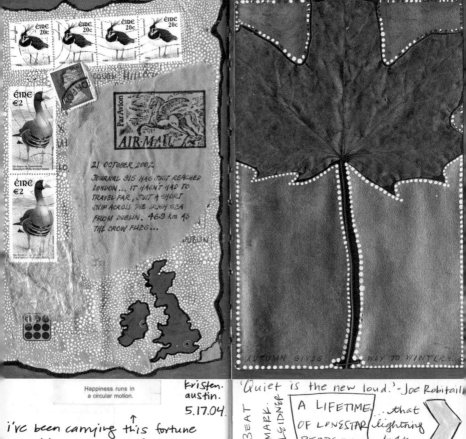

éire 20c (×4) — éire €2 (×2) — éire €2

COUGH Hitler

Par Avion
AIR MAIL

21 OCTOBER 2002.
JOURNAL 915 HAS JUST REACHED
LONDON... IT HASN'T HAD TO
TRAVEL FAR, JUST A SHORT
SKIP ACROSS THE IRISH SEA
FROM DUBLIN. 469 km AS
THE CROW FLIES...

DUBLIN

AUTUMN GIVES WAY TO WINTER...

Happiness runs in
a circular motion.

kristen.
austin.
5.17.04.

i've been carrying this fortune
around in my wallet for about a
month now. i like it because i can't
figure it out. does it mean you have
to have bad to appreciate good? does
it mean happiness is something
you cause in others who in turn
cause it in you? regardless, it just
seems to make some sense to me.

happy → → me nice to you

sad → you nice to me.

and the fact that it doesn't make
total sense is even better - like a
total existence metaphor.

7.8.04

ii. Still kristen here. i understand why
anyone keeps this journal so long—
it poses intimidation—quick! cram
symbolic book into your entire existence!

'Quiet is the new loud.' - Joe Robitail

"LOVERS ARE THE COOLEST. THEIR HEARTS BEAT THE BEST & THEY KISS MAGIC AS HELL." - MARK LEIDNER

A LIFETIME
OF LONESTAR
PERPETUAL
FRIDAY NIGHTS
FOREVER YIELD
TO SATURDAY
MORNINGS WHEN THE SIDEWALK
WAS BED. I CHOOSE TO LIVE
SEMESTER-TO-SEMESTER. I QUIT
LIQUOR BACK IN ATLANTIS;
NO MORE MIDORI MIDNIGHTS,
VODKA AFTERNOONS OR COCONUT
RUM TUESDAYS, NEVER JAEGAR'S
KICK OR LETHAL TEQUILA AT
LAST CALL. HERE I'M ALL BEE
SAFELY SIPPING FROM A KOOZ
LIZZIE GOT ME IN GULF OF
ALABAMA - 'you just seem more
sailboats than dolphin' GREE
GRAPES & BABY CARROTS, FREE
FRANCE SHOTS OF RAIN...

...that
lighting
bolt
was
mine.'
G.G.
Marquez,
of Love & Other
Demo

FAREWELL

JOURNAL ITZ. I ONCE AGAIN HAD HIGH HOPES THAT I COULD CONTRIBUTE SOME AMAZING AND THOUGHT PROVOKING SUBSTANCE. INSTEAD I DO TOO LITTLE WITH THE LITTLE TIME I HAVE FOR SUCH AN AMAZING OPPORTUNITY. SO WITH THIS BOOK AS MY TIME HERE ON THIS PLANET AT THIS PARTICULAR TIME "I WAS PART OF IT."

THANKS

SEAN CLAYTON
VERO BEACH, FL
U.S.A.
12·15

The only legacy I can leave my children is having loved them unconditionally and dying for them without anything in return.

The most memorable event in my life is having constructed the fst Suspension Bridge in the PHILIPPINES crossing the Cagayan River and where I met my loving wife <u>Manitess</u>.

ANGEL G. VILLANUEVA
engineer Consultant
8 Jan 2006

ROTTING IN THE ROUTINE A SLOW GOOP, A SLOW DEATH

NEVER A DEARTH OF CRUST OR DIRT, CAKING EVERY CREVICE OF EVERY STRUCTURE ON EVERY UNEVEN PLANE, A MESSY BUILDUP OF MOVEMENT AND NOISE, A SNOWSTORM OF BUSY AND CHUNKS OF ROTTEN MATTER

ALWAYS WAITING FOR WORM THE WORM CARRIES ME TO WORK ON ITS BACK

THE TRAFFIC IS FUCKING LOUD

LOOK

A LOUD
GROUP OF
GABBING
RIONS "ORBOS"
DOE

PEOPLE BUMPING
PEOPLE OUT OF
POSITION

my heart leaks bloody
bomb sewage all over the
floor.

she gave me cartoon bandaids
 but it doesn't help. elbow
skin and pulsing heart do not
agree with adhesive.

me llamo zoe.

yo vivo en la ciudad de
 Portland.

tengo dieciseis años.
 yo me siento que yo
 tengo nada. y yo
quiero más. ahora.

scott bakeman gave this to me
 today as a cure for my
mangled heart in my throat.
 TODAY IS THE TWO-WEEK
ANNIVERSARY OF MY ABSTINENCE
 FROM WRITING.

Journal 265

Ramallah, Occupied Palestine

The journal was brought to me by my
girlfriend from Holland. I wrote in it about
daily experiences of Palestinians under a
brutal military occupation. I passed it on to
one of my dearest friends, who works for
the same human rights organization.

absorbed in calculation as to the probable age of the hostess.

concentrated s m o k e or diffused banks, power or phone-line breaks,

Running the electric cable is a breeze when ...nish off an attic or make an addition ...ouse. You install the cables after the ...ng is in place and before the walls ...vered. There are none of the "snak-...roblems that you face in an existing ...ure. Here's how a typical job looks.

ng area of 500 sq. ft. ...1,400
3 watts............................. eating five rooms............9,000
20-amp kitchen circuits dryer.............................4,500
conditioner..................... cuit you want to add....2,300
hen range............................. al watts.......................39,680

Continued

s of ready-made ceiling-box brackets and one made from wood

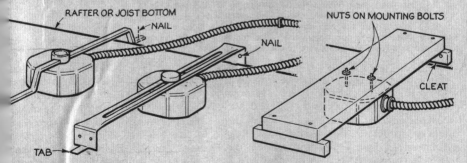

the brackets shown above let you shift
o any spacing you want between rafters.
e locked in position by tightening a nut
e box from below. The tab on the bracket
r (not found on all brands) is designed
the box so it will come flush with the
As the bracket at left is of fairly heavy

the box down a little (after rafter-notching) so it
will still come flush with the ceiling. A cross-
piece supported on cleats provides a firm sup-
port for standard heavy ceiling fixtures. Set the
crosspiece so the box is flush with the ceiling
surface after the wallboard is in place. If you plan
to make or adapt a very heavy fixture, then provide

My life would be a giant mess if

bring your
umberella!

breath

SHIT
HAPPENS

remember that
pain often
inspires great
art...

be happy

make friends
not enemies

Leave a wound
alone if you
want it to
Heal...

things will
get better...

it weren't for POST-IT notes...

meet the love
of my life

11 SEP 2001

cool sites: www.
daneldon . org
nobodyhere. com
superbad . com

pray
every day...

sleep
at NIGHT

get over
HIM!

finish 1000J
and send it
to Martin!

say
"GOOD-BYE!"
(to journal 915)

uncontrol sketches for site V1-V4

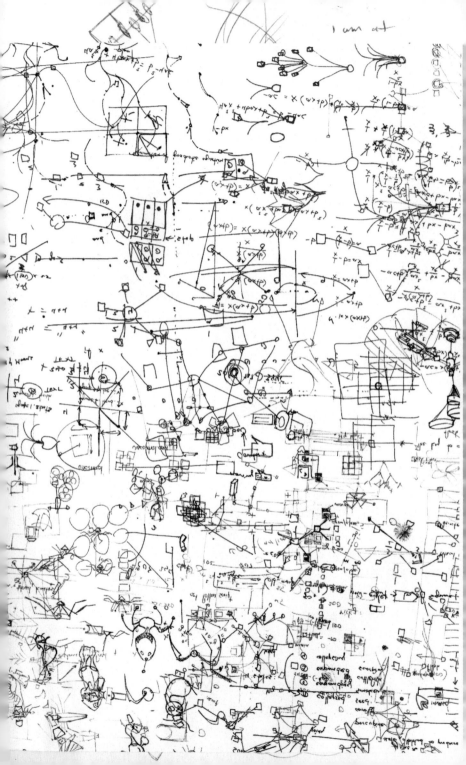

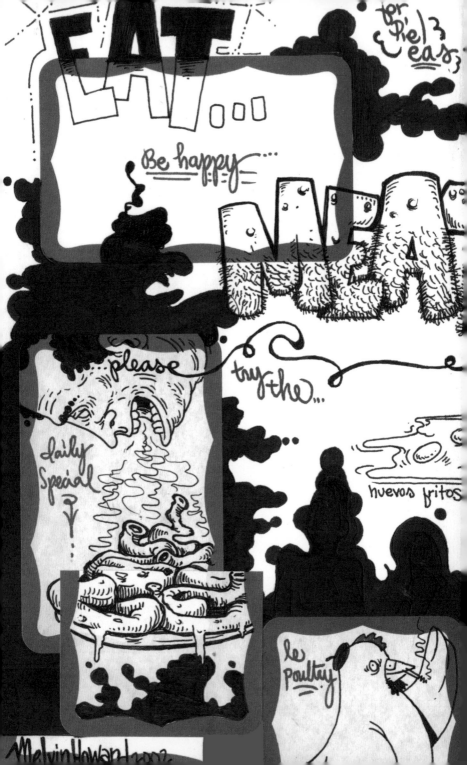

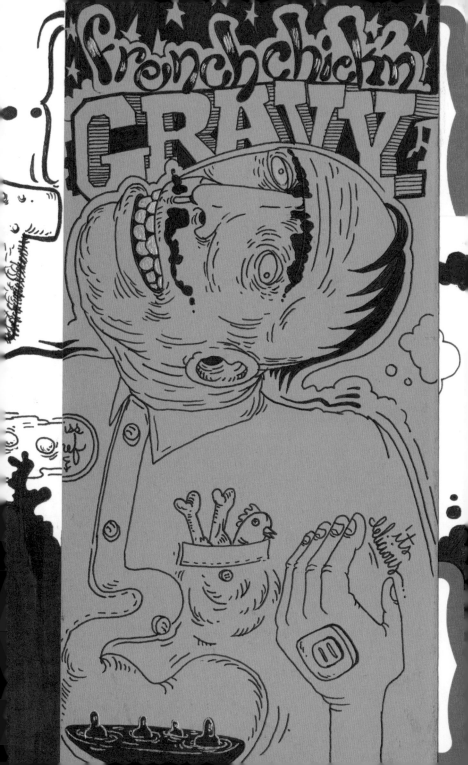

Journal 001

Being one of the first is a big responsibility, but I think I handled it well. I wrote a letter to my grandfather, who I had never met. I promised him that someday, like the journal, I will end up where I belong and that he and I will probably get along great. I left #001 at the Guam International Airport.

Update:

I finally went to the airport a couple months ago to check the lost and found for the journal. They run a tight ship and log all found items in one big book. I scanned the book. No entry. Either an airport employee picked it up and is passing it around or a traveler took it.

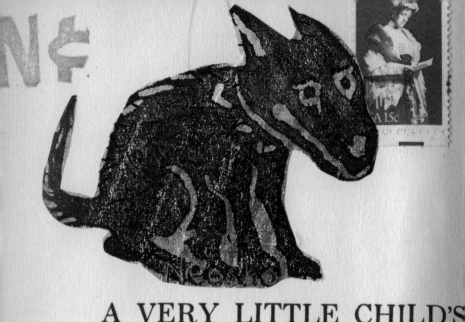

A VERY LITTLE CHILD'S
BOOK OF STORIES

1401

How to
deal with the
painful inevitability
that I must
sometime (soon)
release this journal
from my care
?

you wanted so long to get your hands on one
of these journals. here(it is. now what're you
going to do (it? use it to change the world?

use it to promote world peace and save all
the homeless puppies? really make a difference
for once in your life? no, probably not. no,

carry it around for a while in the unopened
package. *What I want* part of life to you. Zesa is sittin
here. my right, yaking

feeling there's a Miles Davis "D" ori.
dread puter. And I just open
about w day- Zja- roo Always
what ab
quit be out, be
cool. tells me
the en to bonn
my elbeality
these pal today
that is x of stuff
carry it bin Kane). (Merry Christma to e
beauty. eosho! So m resting all the good
will so noryh the contents energy, mystery
book. th l drawer. A cosahar absorb
where. le a our the rent guy
device

PO BOX 08252
CHICAGO, IL 60608-0252
100%
FREE of RIS

significant experiences. what's the point? I
mean, I could just write about all kinds of
significant shit i've doing with this journal
and y'all won't even know if it's true or

Jakarta. 4:13 AM

Temperature 28 degrees, humidity 85 ~~my~~ percent,
cloudy. Why am i having a burntout at this hour?
The worst thing ever that came is having a
~~...~~ sleep. Like i do, now..

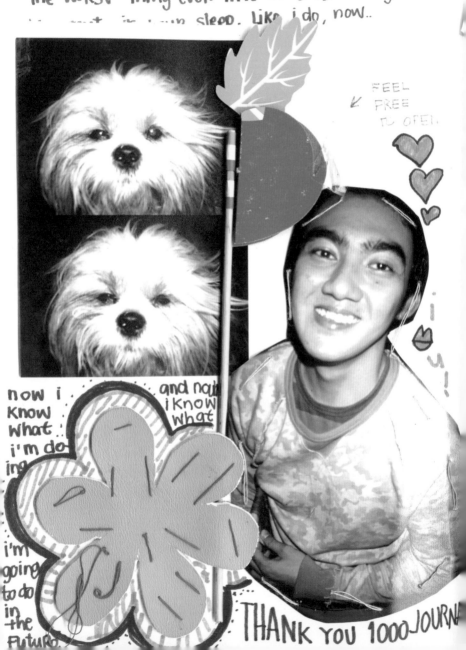

FEEL
FREE
TO OPEN

i
♥ U!

now i
know
what

and now
i know
what

i'm do
ing

i'm
going
to do
in
the
future

THANK YOU 1000 JOURNA

me!

THIS IS WHAT I LIKE
ABOUT MY ROOM..

MY KUBRICKS
COLLETIONS

→ right up my bed; just
me & him. ♡

→ this is where i keep my
magazines &
important
books

↳ the apple & tintin.

↳ the cd shelves.

(i used to have no mini compo
im my room. listened my cd
from the computer).

→ the mini compo,

my favourite
↗ vinyl at the
moment.

grand
music
FLASH

↳ with my turtable on..

←

the 1st
time i've
won a
photographic

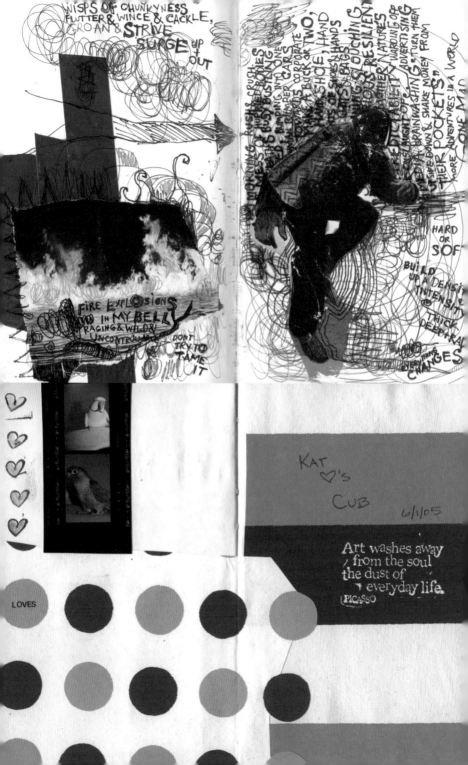

WISPS OF CHUNKYNESS
FLUTTER & WINCE & CACKLE,
GROAN & STRIVE
SURGE UP & OUT

FIRE EXPLOSIONS
IN MY BELLY
RAGING & WILD &
UNCONTROLLABLE
DON'T TRY TO
TAME IT

HARD
OR
SOF

BUILD
UP A DENSI
INTENSI
THICK
DEEP LA

EVERYTHING
CHANGES

KAT ♡'s
CUB
6/1/05

Art washes away
from the soul
the dust of
everyday life.
PICASSO

LOVES

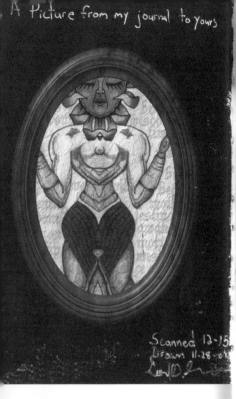

A Picture from my journal to yours

Scanned 12-15
Drawn 11-28-0?

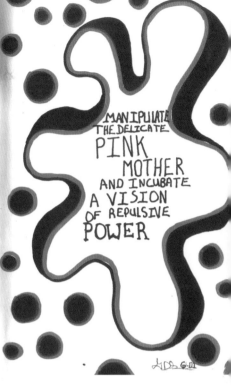

MANIPULATE
THE DELICATE
PINK
MOTHER
AND INCUBATE
A VISION
OF REPULSIVE
POWER

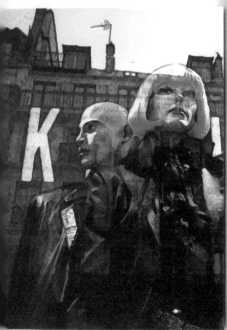

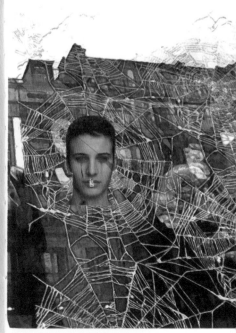

Social order collapsed along with Saddam

XS

but good things come in small packages

OPEN YOUR HEART
AND YOU WILL FIND
LOVE [SEES] only
 When the eyes
 are closed
OPEN YOUR HEART
BEAUTY LIVE IN

heart

 TO LOVE & BE LOVED

AWAKE FROM THE DREAM * Desensitize *
Reprogram Your MIND * Feel Your Toes *
* Kneel ON The Earth * Reach for your
Heart * Breathe the Air * Throw
out your check boxes * Release
your fear * De-construct * Touch
a flower - then smell it's essence -
* Believe in Yourself * Be at ONE

GEMIn
Theater
PRESENTS
fun with

THE

LiaR &

A COUPLA NIGHTS SITTIN' AROUND
HOLLIE'S COFFEE TABLE &
MAKIN' A MESS 1.26.02

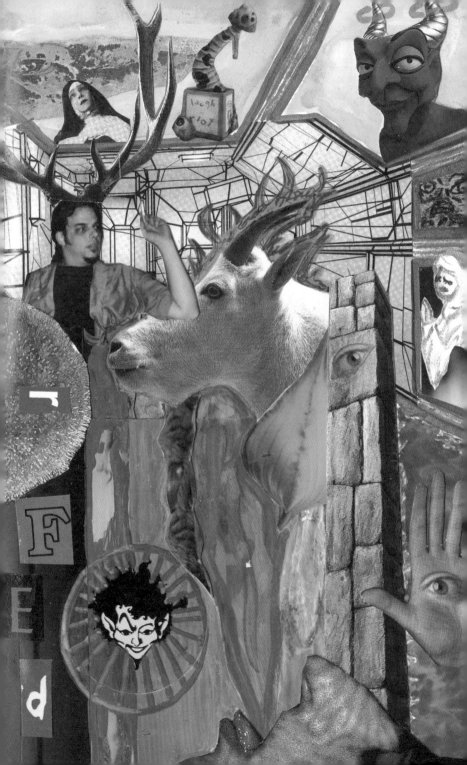

Journal 354

St. Louis, Missouri

My crew and I were headed down the Mississippi River on a pirate ship that we cleverly disguised as a river barge, on our way out to sea.

Our final destination is to rob and pillage Cuba of their hidden gold reservoirs. It has already been several days since we set out from our post in Canada (sorry, I can't tell you more; it's a secret location), and my soldiers are already getting restless. We have decided to visit St. Louis for a while. St. Louis is a fabulous place filled with many strange sights and wonders. The first obvious landmark is the arch, which, albeit seen as a tourist attraction and general waste of space, truth be told: at midnight, it is often used as a trans-dimensional gateway.

The men split apart to study different areas of the land. Cadet Staples, our experienced guide and eldest of all of us, set off by himself to visit Forest Park. He plans to visit the great statue of Saint Louis himself, who (as legend would have it) guards the art museum from evil spirits.

Another group of men have been sent to invade the botanical gardens to pick exotic floral decorations, which we will use to woo the luscious Cuban women. The largest group of men went in search of a pub with good aged rum. They have been instructed to return with no less than ten barrels. Lastly, I have sent ten men to the city museum (which was designed by Cassilly, a former crew member of mine) to kidnap a large, burlap sack full of children to barbecue for our dinner tonight. The city museum was secretly designed for that specific purpose alone.

Only eight hours have passed since we landed in St. Louis, and already we are running into problems. Our bookkeeper, Ransom, has spent all of our money at the President casino. My battalion expert was killed by the crime lord of St. Louis, rap star Nelly, and hundreds of swash-buckling crew members have fallen into an open vortex at the St. Louis Science Center, which is cleverly disguised as an observatory. To make matters worse, my boat, *The Natasha,* was compromised into the hands of local authorities when a spy tipped them off to our mission. I swear if I find out who is responsible for this mutiny, I shall cut out his tongue and feed it to my dogs! I avoided capture by hiding in Dogtown and I plan to hijack a landship for transportation. This is my last hope. I must free myself of all luggage, including this, my ship's log. I am going to hide it in the throat of a giant snapping turtle named "Dick." I pray that it be returned to me in the future. If not, please fulfill my quest and log your account in this book.

With great sorrow,
Captain Long Jon Silver

OUTBACK
STEAKHOUSE®

RECEIPT

3069 MASTUYAM

Chk 6041 06Jul'04 19:35 Gst 2

Closed Check
Reprint

1 CHEESE	945
1 WINGS	1039
2 COLD BEV.	818
CASH	5002
Subtotal	2802
Amt. Paid	2802
Change Due	2200

-------1109 06Jul'04 20:02-------

PAID

OUTBACK
STEAKHOUSE®
MAKUHARI

Messe Amuse Mall 1F,1-8 Hibino,Mihama-ku,Chiba-shi,Chiba

シネプレックス10
幕張

Cineplex シネマ5
（字）スパイダーマン2
SPIDERMAN2
7月11日（日）
21:00 開映 G-13
レイト　1,200円
●上記の日時1回限り有効
●払い戻しはいたしません
034

These are 2 dates we went on. Shawn held my hand when I was scared in Spiderman 2. I stole him a toothpick from the bathroom so we could smooch (from the Outback)

WHEN IT STARTS
RAINING I GET INSPIRED.
I WANT TO MAKE POT AFTER
POT OF COFFEE AND
PAINT FOR HOURS. BUT
WHEN IT
JUST KEEPS
RAINING, I
DON'T WANT
TO DO ANYTHING.
JUST WANT
TO HIDE IN
MY BED. AND I HATE
HOW DEPENDANT I AM
IN THE SUNNY CALIFORNIA
WEATHER. I HATE HOW
MY MOOD IS SO EASILY
CHANGED BY THE
SUN OR ITS LACK.

I WANT TO
BE MORE
STABLE.

be subject to one another

watCHED HER SIP SO ME COFFEE
ND PRETEND THAT SHE was sleeping
YET HER SILENCE WAS ENDEARING
sO told her
that i loved

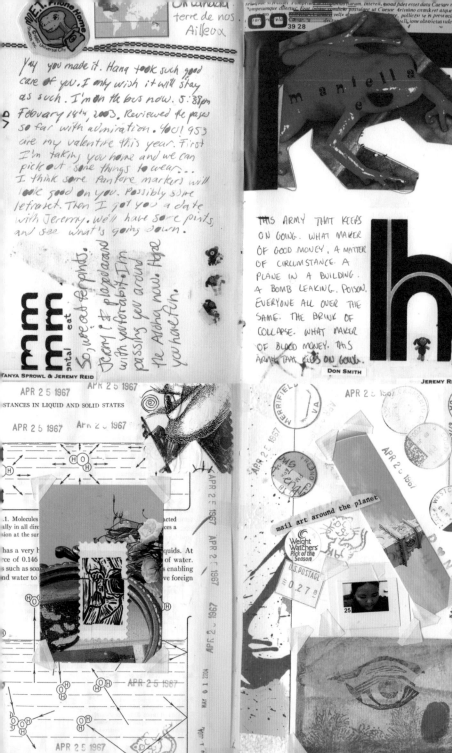

On Canadian terre de nos Ailleux

E.T. Phone Home

39 28

m a n t e l l a
e

Yay you made it. Hang took such good care of you. I only wish it will stay as such. I'm on the bus now. 5:38pm February 14th, 2003. Reviewed the pages so far with admiration. You! 953 are my valentine this year. First I'm taking you home and we can pick out some things to wear... I think some Pantone markers will look good on you. Possibly some letraset. Then I got you a date with Jeremy. We'll have some pints, and see what's going down.

So, we eat for pints. Dream I eat placed around with you for abit. I'm passing you around the Aloha now. Hope you have fun.

mm mm ntal eat

TANYA SPROWL & JEREMY REID

THIS ARMY THAT KEEPS ON GOING. WHAT MAKER OF GOOD MONEY. A MATTER OF CIRCUMSTANCE. A PLANE IN A BUILDING. A BOMB LEAKING. POISON. EVERYONE ALL OVER THE SAME. THE BRINK OF COLLAPSE. WHAT MAKER OF BLOOD MONEY. THIS ARMY THAT KEEPS ON GOING.

h

DON SMITH

JEREMY REID

APR 25 1967
APR 25 1967
APR 25 1967
APR 25 1967

STANCES IN LIQUID AND SOLID STATES

H—O—H

1. Molecules ... acted ally in all dire... ces a sion at the sur...

has a very h... liquids. At rce of 0.146 ... of water. s such as soa... s enabling nd water to ... ve foreign

mail art around the planet

Weight Watchers Pick of the Season

U.S. POSTAGE 0.278

25

APR 25 1967

MERRIFIELD VA

FRESNO CA

WESTCHE

CA

KAWE...

over the rainbow

i've been feeling so bored & lack of inspiration over the past 2 weeks. & i've been wanting to do something or go away somewhere, out of this world. i need an enlightenment, i need you...

i climbed the tree, there i found you. Somewhere in the darkness...

there you
read
my
ha...

!yes, yes, yes!! #896 has finally here!!
i have waited for about 1.5 years ★★

i love the smell of this journal... mmhh!! 😊

I fell in LOVE
with you
WHEN the
RAINY SEASON CAME
& i forgot about god

Sept 20 '03

me & march

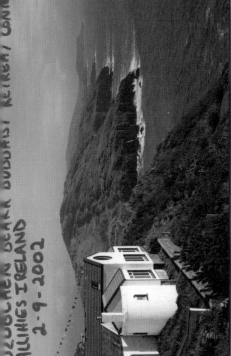

JOUDCHEN BEACH BUDDHIST RETREAT / CONNER
BALLINIS IRELAND
2-9-2002

MURPHY'S BAR
18 COLLEGE STREET
KILLARNEY

Hey, if you ever in Killarney Ireland County Ker come to Murphys where I work.

Ask for Ashly, I am a canadian that has been work here for the last 6 months. I is a blast so get your butt down here!
Slànte
YAH CANADA!!
-Ashly

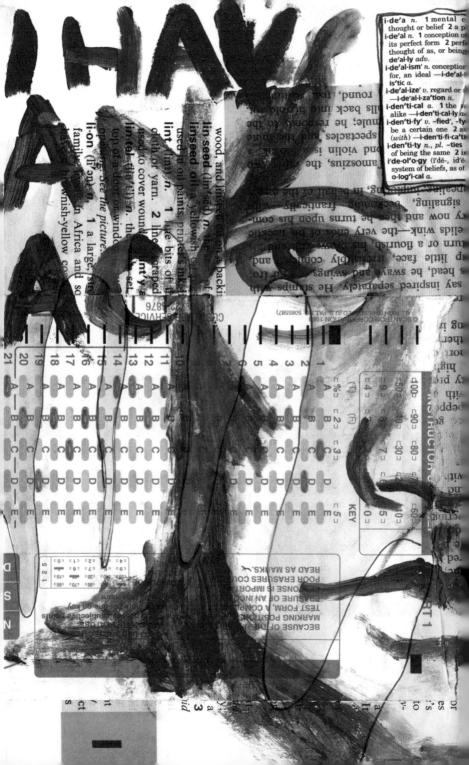

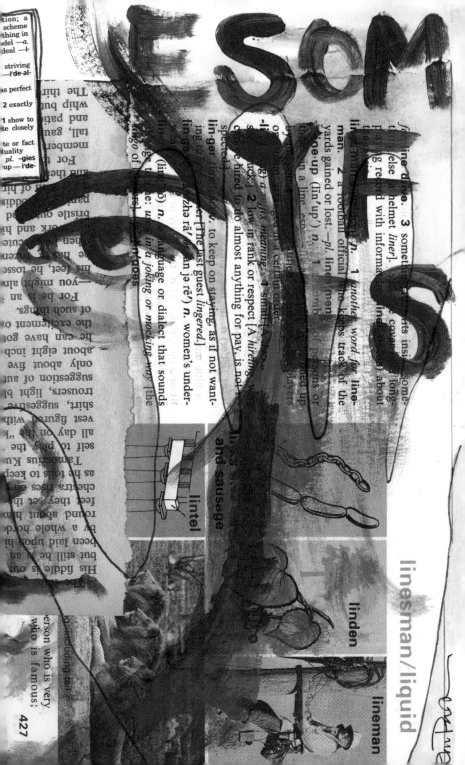

I grew up in a country called
Bahrain. Its a small island
near Saudi Arabia. If you've ever
been there Woohoo! + if you went to
School there — St Chris or Bahrain High sch
Then we might even know eachother.
It's weird growing up in such a small
place — you kinda have this. Connection
with everyone there — even if you weren't
close, or in the same year.
Its like you all shared this very different
experience — something really unique + its
a bond for life.
Walking down the Streets of NYC +
bumping into people from Bahrain is
even wierder! —
Growing up was great — I have really
fond memories of hanging out at peoples
houses, Swimming, renting a bus to take
a whole bunch of us to the beach.
There were def times when we all
Sat around listening to the guys Jam away
and thought — ugh if we lived anywhere
else we'd have loads to do —
I guess everyone thinks that.
Bahrain is famous for the "tree of life"
this huge tree that grows in the middle
of the desert.
It was not like you'd expect — an oasis

country. We had bars, clubs, movie theatres
(well only one when I was growing up + it showed
Indian movies nearly all the time except for some
weekend times when U.S. films would show)

I am a mutt! a mix of Egyptian + Chinese,
with an Englishman for a stepdad (who was
pretty much there since I was born). so he's
my Dad

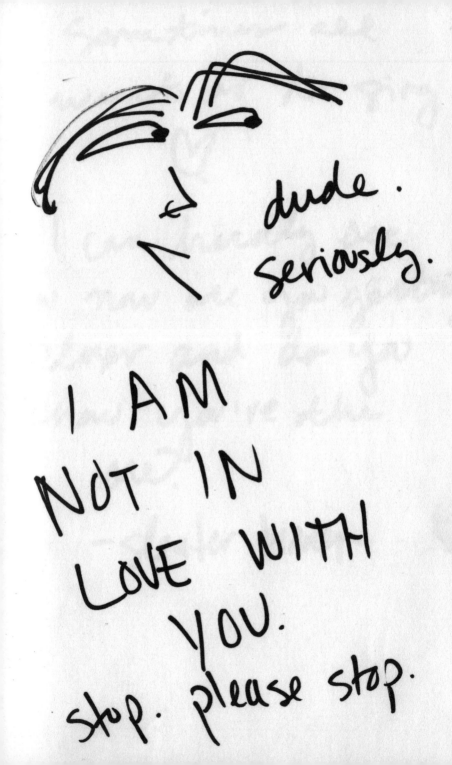

Journal 497

Barrington, Illinois
I took my journal on a bar crawl. Among
many entries, I got a drawing done by a
quadriplegic man who drew using his mouth
to hold the pen. The two girls who worked
the bar took three hours to cut up their girly
magazine and assemble a collage. I drew a
big carrot. I sent it to an architect in Florida.

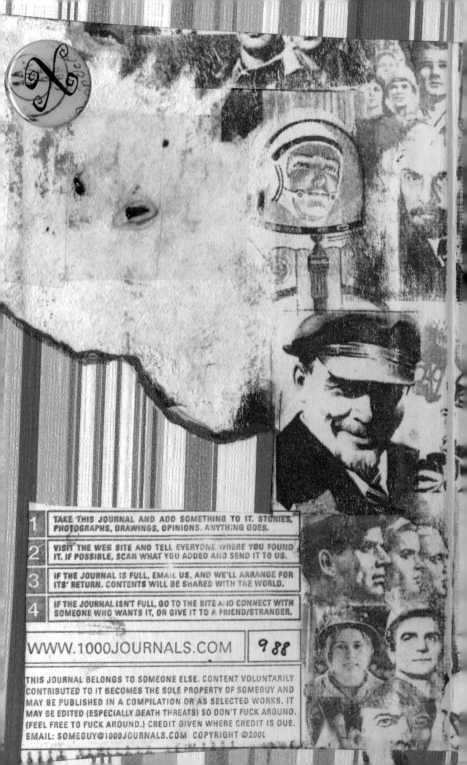

1	TAKE THIS JOURNAL AND ADD SOMETHING TO IT. STORIES, PHOTOGRAPHS, DRAWINGS, OPINIONS. ANYTHING GOES.
2	VISIT THE WEB SITE AND TELL EVERYONE WHERE YOU FOUND IT. IF POSSIBLE, SCAN WHAT YOU ADDED AND SEND IT TO US.
3	IF THE JOURNAL IS FULL, EMAIL US, AND WE'LL ARRANGE FOR ITS' RETURN. CONTENTS WILL BE SHARED WITH THE WORLD.
4	IF THE JOURNAL ISN'T FULL, GO TO THE SITE AND CONNECT WITH SOMEONE WHO WANTS IT, OR GIVE IT TO A FRIEND/STRANGER.

WWW.1000JOURNALS.COM 9 88

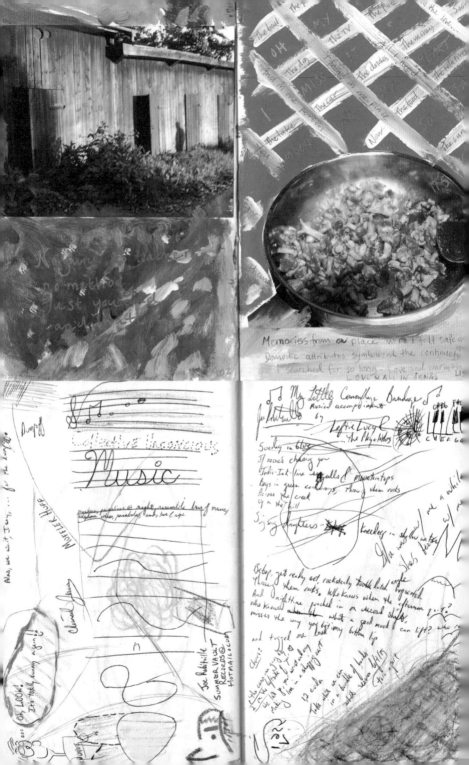

Memories from our place where I felt safe and
Domestic attributes symbolized the continuity
I searched for so long. Love and warmth.
LOVE Y'ALL IN ARNÁS LH

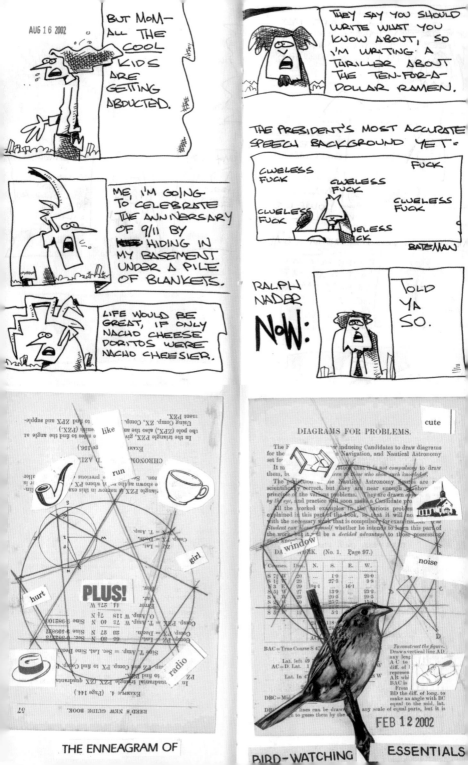

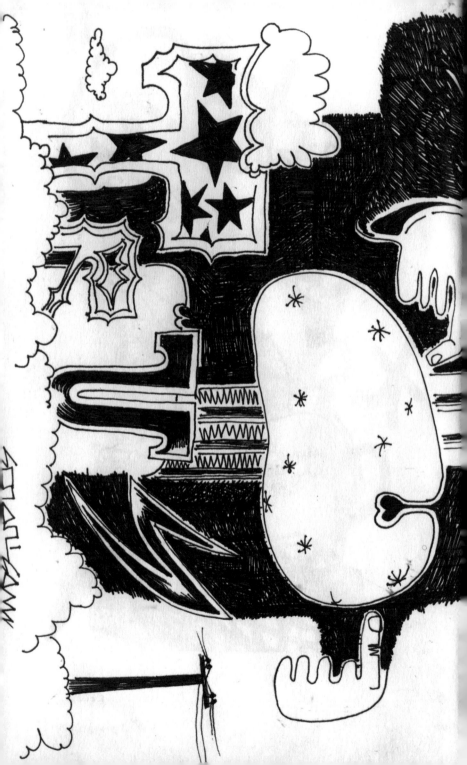

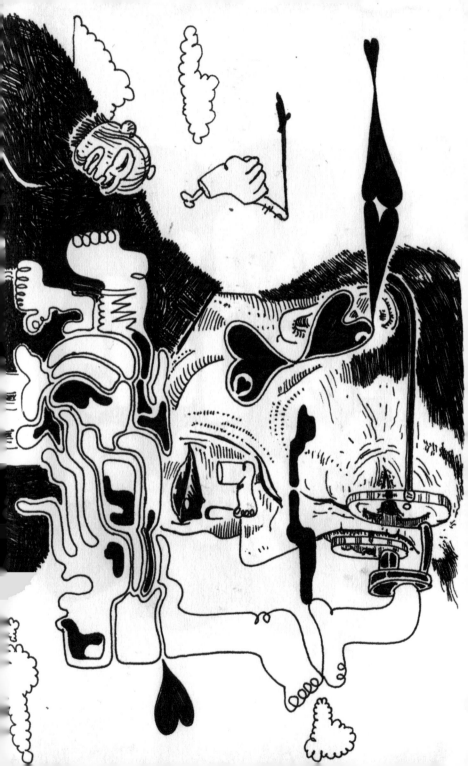

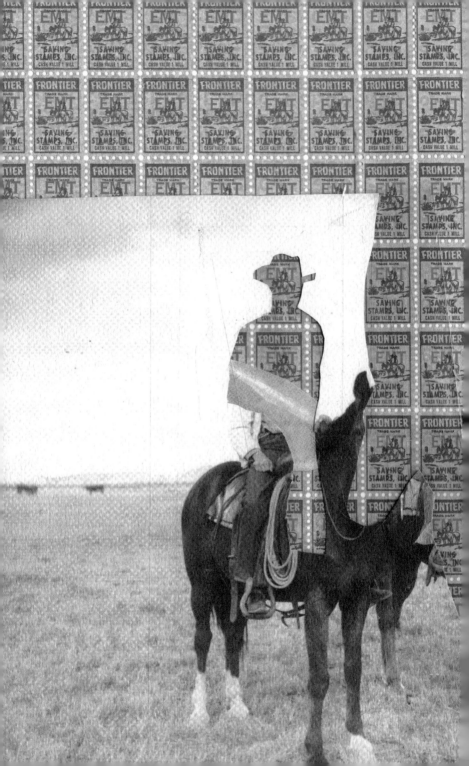

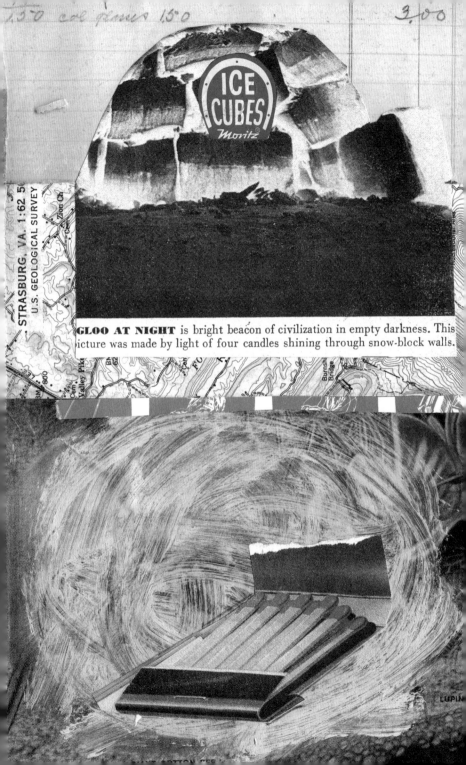

ICE CUBES *Moritz*

GLOO AT NIGHT is bright beacon of civilization in empty darkness. This icture was made by light of four candles shining through snow-block walls.

Actual transcript of a radio conversation of a U.S. naval ship with Canadian authorities off the coast of Newfoundland in October 1995. Radio conversation released by the Chief of Naval Operations 10-10-95.

Americans: Please divert your course 15 degrees North to avoid a collision.

Canadians: Recommend you divert YOUR course 15 degrees to the South to avoid a collision.

Americans: This is the captain of a U.S. Navy ship. I say again, divert YOUR course.

Canadians: No. I say again, you divert YOUR course.

There is some debate as to whether this is a true story or an urban legend. It has followed the typical proliferation pattern of an urban legend on the Net, even being reported as fact in some newspapers. The Navy, of course, denies it.

Americans: THIS IS THE AIRCRAFT CARRIER USS LINCOLN, THE SECOND LARGEST SHIP IN THE UNITED STATES ATLANTIC FLEET. WE ARE ACCOMPANIED BY THREE DESTROYERS, THREE CRUISERS AND NUMEROUS SUPPORT VESSELS. I DEMAND THAT YOU CHANGE YOUR COURSE 15 DEGREES NORTH, THAT'S ONE FIVE DEGRESS NORTH, OR COUNTER-MEASURES WILL BE UNDERTAKEN TO ENSURE THE SAFETY OF THIS SHIP.

Canadians: This is a lighthouse. Your call.

Journal 587

Tucson, Arizona

The journal was given to me in Brooklyn.
I then left for Arizona with my girlfriend.
Me and the woman are no more, but I
finished my part of the journal. I am now
sending it to a friend that I hurt so much
he is no longer my friend. Hopefully this
will make him happy.

New York, New York

It came wrapped in white computer paper
bearing my name, without postage, and
I knew immediately who it was from, that
asshole who I had already forgiven for
ruining our friendship, but was still not
going to waver in my decision to tell him
to fuck off.

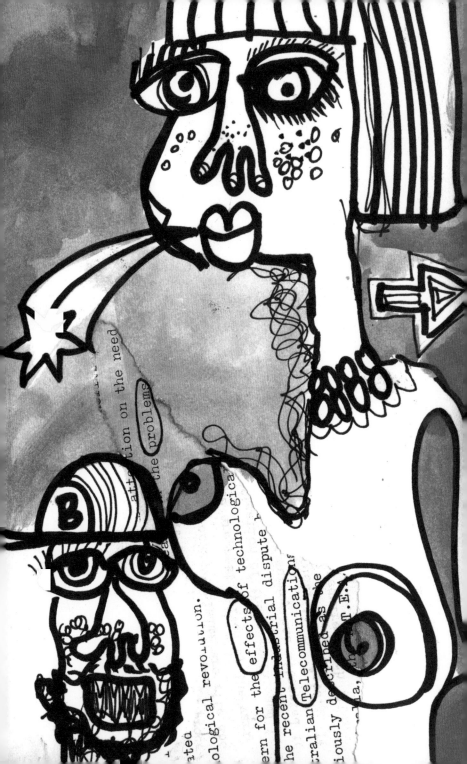

attention on the need

the problems

effects of technological

the recent industrial dispute

tralian Telecommunications

iously described as the

...T.E...

...ralia,...

...ern for the...

...ological revolution.

...ated

WHAT ARE YOU LOOKING AT

Components of the traditional Little Black Dress Night...

Lady J's
Pink Kink
Mai Tai

ESTROfest — a much-needed celebration of femininity by grrrl geeks who don't always want to play with the male techies.

INSPIRATIONS?

- Naomi Wolf (author of the Beauty Myth)
- Pre-Rapaelite artists
- Audrey Hepburn in "Breakfast at Tiffany's"
- Cosmo Quizzes
- Bond Girls
- Going to bars where nobody pinches your ass
- Stilettos (the daggers and the shoes!)

1 oz coconut rum (or more ...)
1/2 oz orgeat (almond syrup)
1/2 oz lime juice
2 oz cranberry juice
a few strawberries
ice

— blend, garnish with lime wedge & umbrella, and ENJOY!

- drink with suggestive names... oh so witty.
- GOSSIP & ADVICE
~ the belief that EVIL is another word for — Ally McBeal, Barbie, Britney Spears, Bill Gates, the RIAA, nylons, stilettos, Republicans, cheerleaders, MISOGYNISTS, the SIZE IS fascist fashion industry and all oppose free speech, education

It's that sexy dress that hangs lonely in your closet, waiting for an occasion worthy of it. Why wait for a time when you want to impress someone? Impress yourself. Take yourself out on the town for some friends-only fun. It's a Grrrlz Nite Out (grrrlz freely defined) just for the pleasure of being all dressed up with somewhere to go. (And the little black dress might be a flippy skirt or a pair of leopard print pants.)

3D PICZ

TAKE A LOOK WITH THE VIEWER

LIKE THIS ONE.

THREE DEEE PIC

WE ARE HERE VISITING TO FAR OUT COOL CITY OF **PORTLAND**!!, I LOVE IT HERE. ~TRACY MOORE

DRAW @ BLUE MOON TAVERN IN "BOHEMIAN" PART OF WORLD IN PORTLAND, OR ~ WE ARE ON A MISSION TONIGHT TO COLLECT PICS AND DOODLES! FOR JOURNAL #536 ↗

HEY!!!
USE THIS HANDY DANDY 3D VIEWER TO VIEW THE 3D PICS WHICH ARE PLACED THROUGHOUT THIS JOURNAL!

3D

ST... LOMO SPY CAM SHOT S↗

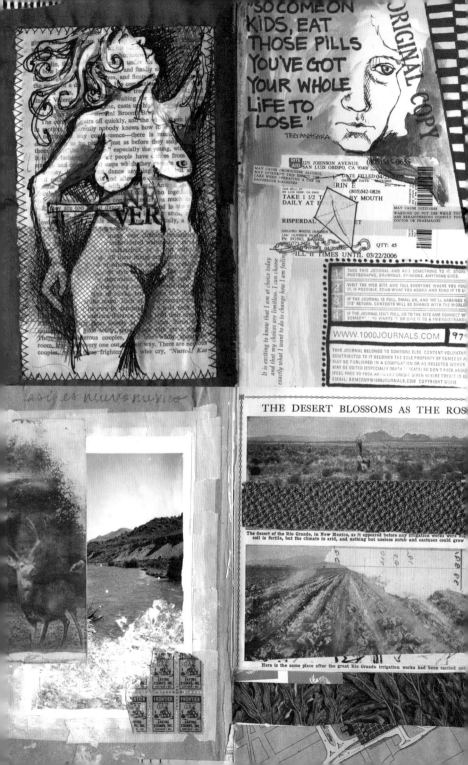

And she said she doesn't want to
talk about it... of course

SHE IS LYING TO YOU

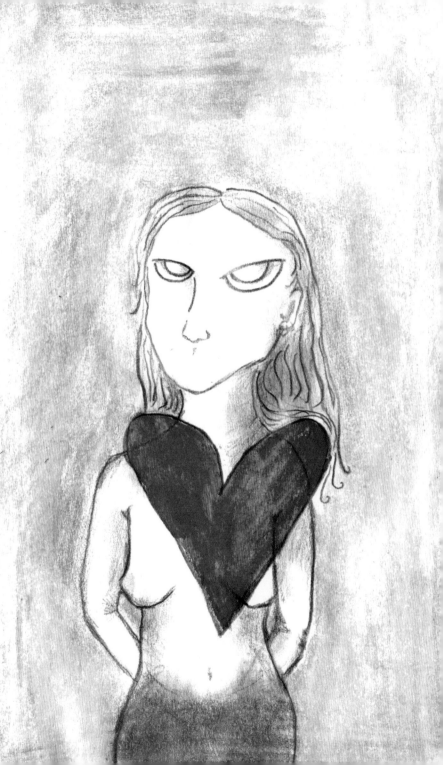

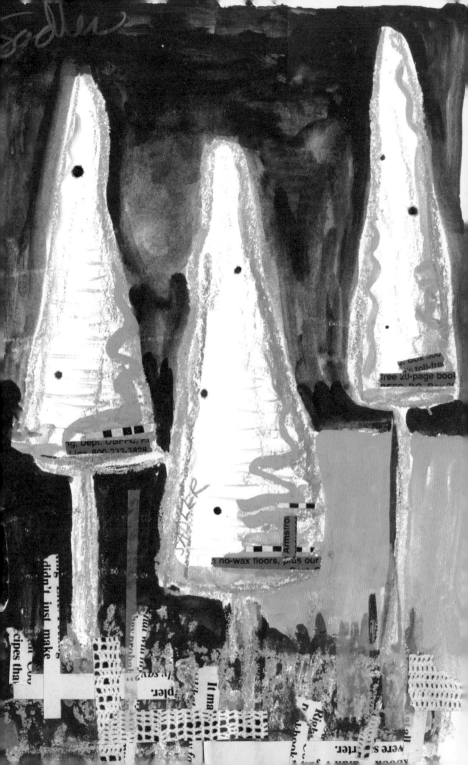

In the spirit of the "wicked" book, I'm afraid it's predestined to have a very scandalous and depraved existence. In my hands, the journal accumulated:

- a drawing of the balcony grillwork at Maya Taqueria in San Francisco.

- an unsigned sketch by the artist Skriblz

- a diary entry of a night out with three friends (including a story about a house party that had an unfortunate experience with tracked-in dog poo—ick!)

- a picture of a girl who I think lived in my house before me, but I am not sure.

- a photo from a journey to Sedona, AZ.

Just "Z" it

"Z"

...my friend...

Um imenso exército de amor que se
movimenta e se espalha sobre todas
as faces da terra, semelhante à
estrelas cadentes que veem iluminar
o caminho e abrir os olhos dos
cegos.
Quando sonhos e palavras
chegarem ao seu verdadeiro
sentido, trevas serão dissipadas,
para confundir os orgulhosos e
glorificar os justos.
Que vossas vozes se unam e,
num hino sagrado, se estendam
e vibrem de um extremo do
universo ao outro. Que sejam
gritos e sussuros pelo amor e
paz no espírito, pedindo um
dia ainda melhor para amanhã.

Cristiane Giamas, 21 years old, born in
são paulo, brazil, learning, loving,
crying, smiling, dreaming, living,
wishing and hoping.
Do believe in love at first sight and
that remarkable moments are the greatest
thing. NEVER regret. You can't lose what
you never had. Make me laugh, make me
cry and don't tell me why.
Truth *beaty *freedom *love *peace!

São Paulo, Brasil - 24/oct/03 - 14:00 -

patsyplus@hotmail.com / www.fotolog.net/cristi

1918
Hyde
A16

Experiment

MY DAUGHTER WHO IS A COMPETITION CURRER

pamela joutras

Metals & Mixed Media Artist

Overprinted in Green

AGE 41, ARTIST
WIFE, MOTHER

WHO HAS
REAL ^{time} ISSUES

- THERE IS
NEVER
ENOUGH
TIME

1939
103 A14 2p bright carmine
104 " 3p deep ¹ : e
Issued in count—
of the Consti

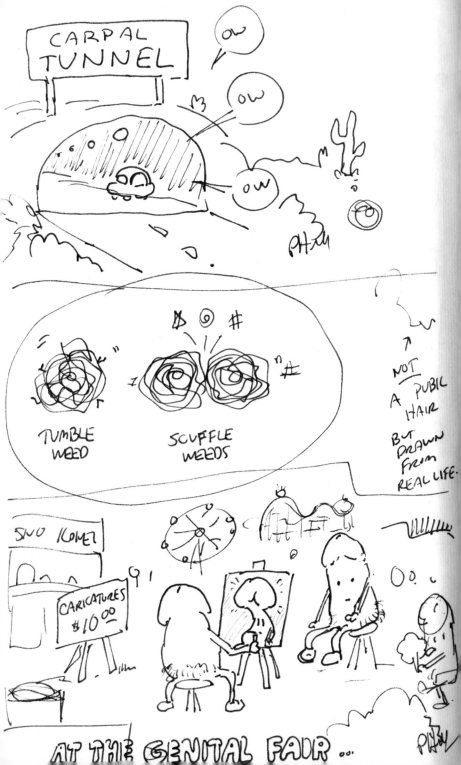

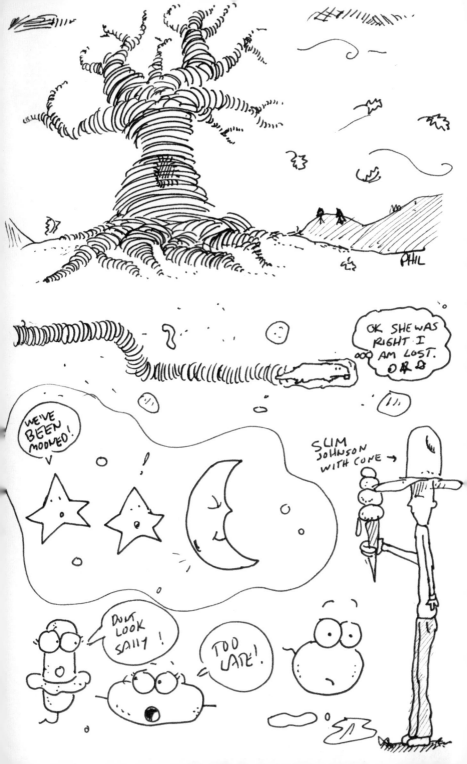

telephone doodles...

SNOWBALL ALERT

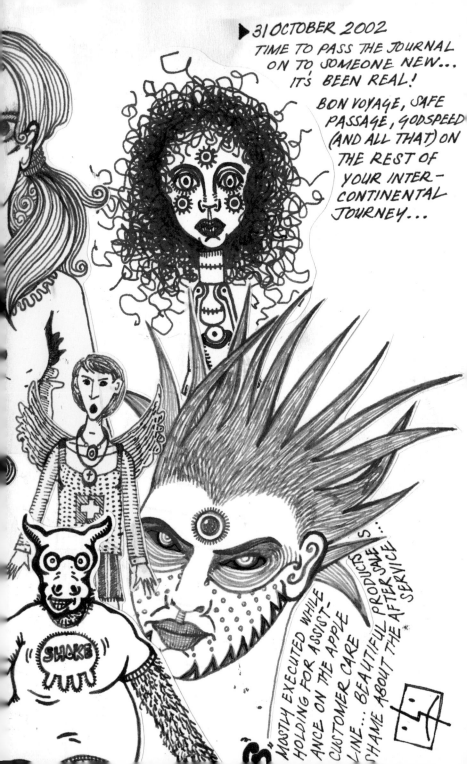

▶ 31 OCTOBER 2002

TIME TO PASS THE JOURNAL
ON TO SOMEONE NEW...
IT'S BEEN REAL!

BON VOYAGE, SAFE
PASSAGE, GODSPEED
(AND ALL THAT) ON
THE REST OF
YOUR INTER-
CONTINENTAL
JOURNEY...

SHAKE

MOSTLY EXECUTED WHILE
HOLDING FOR ASSIST-
ANCE ON THE APPLE
CUSTOMER CARE
LINE... BEAUTIFUL PRODUCTS...
SHAME ABOUT THE AFTER SALE
SERVICE

Journal 913

Brooklyn, New York

It's not as easy as it looks. I've seen some AMAZING things in the pages of these journals. Just wait until it's your turn; and it keeps staring at you, calling to you. Put something worthy on these pages to show the world. It's the albatross around your neck, begging for potential greatness. It becomes your adopted baby, for that time. Or not. Maybe it's my personal neurosis. It's scanned. It's off. It's all GOOD things. I pass it on with the utmost sentimentality. Take care of her.

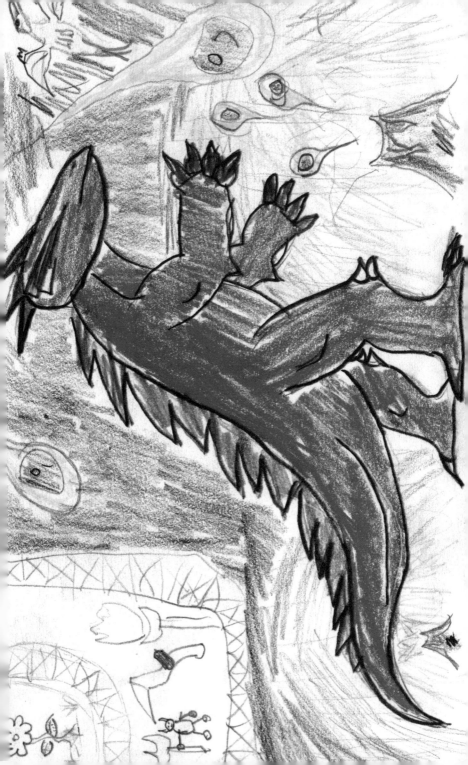

Nicotiana sylvestris

Penstemon strictus

Linum perenne

Phacelia campanularia

Centaurea cyanus

Brassica oleracea

Sisyrinchium bellum

Datura meteloides

Origanum majorana

Allium schoenoprasum

Ocimum basilicum
citriodorum

everyone who
I work with is
a Scorpio &
all of us get
along. That's
me plus 6
others, or 7
out of every
3 people,
so I've been
wondering
what the
connection
is and I've
decided th-
what it is
is that Pla-
are ALL ABO-
SEX, DEAT-
and REBIRT-
maybe not i-
that order,
three things
that Scorpi-
are notably
close to. A-
my dear
friend D
says, "Flo-
are just like
Yeah. Fuc-
me." Plant-
are sexy
and in the
process of
their cult-
vation y-

in America
when we so-
death and v-
it like enter-
tainment. I-
short, it's g-
watching fr-

that is dis-
more than
many of us
'hobbyists' a-
Cadillac's real-

funny thing-
brutal and
casual and
witness to th-
on the tim-
their belief-
decisions of-
life and death
in a single
on a garden-

a-

BABY BLUE EYES

EYES

EYES

NEMOPHILA
Fragrant blue trumpet-shaped flowers. Use for edging, rock gardens.
HOW TO GROW:
Plant in full sun 9" (23 cm) apart. Grows to 12" (30 cm) tall.

NEMOPHILA
Fragrant blue trumpet-shaped flowers. Use for edging, rock gardens.
HOW TO GROW:
Plant in full sun 9" (23 cm) apart. Grows to 12" (30 cm) tall.

NEMOPHILA
Fragrant blue trumpet-shaped flowers. Use for edging, rock gardens.
HOW TO GROW:
Plant in full sun 9" (23 cm) apart. Grows to 12" (30 cm) tall.

NEMOPHILA
Fragrant blue trumpet-shaped flowers. Use for edging, rock gardens.
HOW TO GROW:
Plant in full sun 9" (23 cm) apart. Grows to 12" (30 cm) tall.

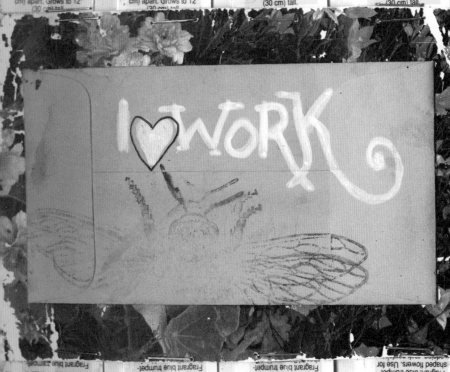

I ♥ WORK

10·6·2005

I started keeping a journal back in 1970, when I was a freshman ART MAJOR at Kent State University. I used books just like these, except they were 8½" x 11"... a good size for sketching ideas for projects & recording dreams, ideas, vital information. I still have some of my early journals, & it's so interesting to read through them again.

During the 80's & 90's I sold out to big business & devoted my life to making a name for myself in the business world. No journals from those years... what a waste.

So in 2000, disillusioned with my climb up the corporate ladder... I made it all the way to "middle management"... the layer that gets "DOWNSIZED" FIRST... I'm just trying to make an honest living & getting back to my creative side. I'm keeping a personal journal again, and plan

to continue to do so until the day I die. Life takes us in ma directions, and it seems impo to document it through jourr That is what I find so very fascinating about this projec It's interesting to see what oth add to the journals, and an adventure to add stuff. M current direction tends to collage, stamping & paper ar I'm starting to get back to sewing, quilting & fiber ar My goals are to return to sketching & watercolor... th I haven't explored since the 70's...

WHAT A LONG
STRANGE
TRIP
IT'S BEEN...

PEACE

A SUFFOCATING SENSE OF BOREDOM

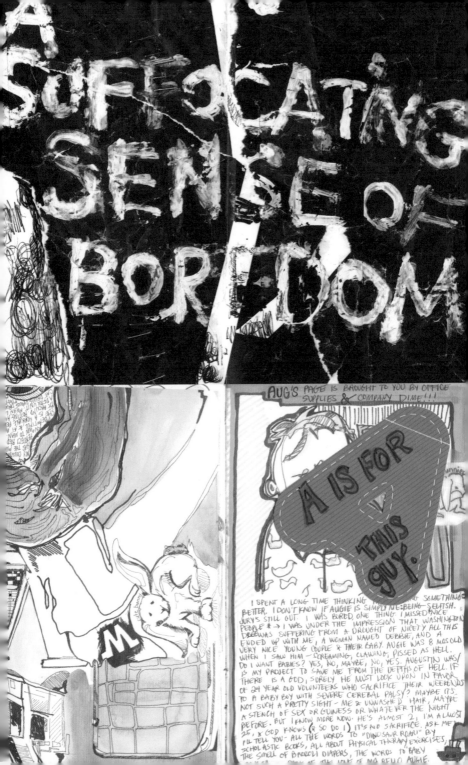

AUG'S PAGE IS BROUGHT TO YOU BY OFFICE SUPPLIES & COMPANY DIME!!!

A IS FOR ∨ THIS GUY.

MY little bunny

I SPENT A LONG TIME THINKING ABOUT SOMETHING BETTER. I DON'T KNOW IF AUGIE IS SIMPLY ME BEING SELFISH. JURY'S STILL OUT. I WAS BORED. ONE THING I MISSED? NICE PEOPLE & → I WAS UNDER THE IMPRESSION THAT WASHINGTON DC WAS SUFFERING FROM A DROUGHT OF NICETY. ALL THIS ENDED UP WITH ME, A WOMAN NAMED DEBBIE, AND A VERY NICE YOUNG COUPLE & THEIR BABY. AUGIE WAS 8 MOS OLD WHEN I SAW HIM — SCREAMING, CLAWING, PISSED AS HELL. DO I WANT BABIES? YES, NO, MAYBE, NO, YES. AUGUSTIN WAS/ IS MY PROJECT TO SAVE ME FROM THE DEPTHS OF HELL. IF THERE IS A GOD, SURELY HE MUST LOOK UPON IN FAVOR OF 24 YEAR OLD VOLUNTEERS WHO SACRIFICE THEIR WEEKENDS TO A BABY BOY WITH SEVERE CEREBAL PALSY? MAYBE ITS NOT SUCH A PRETTY SIGHT - ME & UNWASHED HAIR, MAYBE A STENCH OF SEX OR GUINESS OR WHATEVER THE NIGHT BEFORE. BUT I KNOW MORE NOW. HE'S ALMOST 2, I'M ALMOST 25, & GOD KNOWS (& SO DO I) IT'S NO SACRIFICE. ASK ME I'LL TELL YOU - ALL THE WORDS TO "DINOSAUR ROAR!" BY SCHOLASTIC BOOKS, ALL ABOUT PHYSICAL THERAPY EXERCISES, THE SMELL OF BROCOLI DIAPERS, THE WORDS TO BABY SONGS, THE LOVE OF MR BELLO AUGIE.

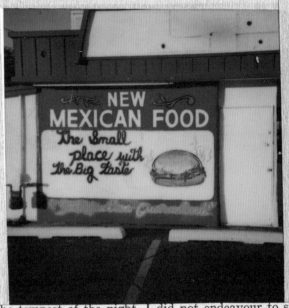

NEW
MEXICAN FOOD
The Small
place with
The Big Taste

the tempest of the night. I did not endeavour to stifle
my cough when the lady gave a peep into it; so it
reduced the case in course to this alternative—that the
lady should sacrifice her health to her feelings, and
take up with the closet herself, and abandon the bed

THE WORLD'S FAVORITE CHEES

*central
ave, abq*

Iliacus; while its extremity affords attachment to the inguinal ligam
origin to the Sartorius. Beneath this eminence is a notch from which
takes origin and across which the lateral femoral cutaneous nerve p

FIG. 229.—Right hip bone. External surface.

the notch is the **anterior inferior iliac spine**, which ends in the in
acetabulum; it gives attachment to the stra
to the iliofemoral ligament of the hip-joint.

I wash dishes At at restraunt. I smoke Pot every day.
I'm 18yrs old. I'm a scinor in high school. I've been
dating the same girl for 10 months, I've been sleeping
with her for 9. Everyday I dream of fortunes and
riches, life without complications or responsibility.
My friends are all adicted to Meth. It is refreshing
to see something like this in my town, a
Vauge monument of creatiuness and individuality.
Mabey the banana Peel wouldnt be so bitter if
God wasnt so oblivious.

- C.M.

Theres talk around town
a town I've never seen
about a boy with dreams
bigger than God
"thats nice" they say
"hell go nowhere" they say
instead he'll stay in that town
slowly wasting away
until a girl with ~~blue~~ eyes
and a great big heart
~~comes to see what this boy has to say~~
that girl comes to see
what ~~this~~ boy has to say
in a big rough city by the bay
It was love, love, love
it was

Journal 981

Fremont, California

Journal #981 reached me a day before I left for New England to look at college prospects. I wrote a lot about my experience, sharing it with friends there. It was stolen from me back home in California, in a book bag. I am sorry I haven't spoken up before now, and that this robs you of a chance to participate. Hopefully whoever has it now joins in the project.

Update:

Today journal #981 showed up in my school's lost and found! I've been checking, and couldn't believe it. It hadn't been added to, but now that I have it back again, I'm sending it on immediately.

Pisces)(

Big Bang

Black Hole

omega Alpha

Alpha

→ DEEP SHIT!
(But No Ego...
May I die a
humble
person.)
PLEASE

Hypercube

Side Note:
Art is Satanic!!! Art is a
society of the elite that
does not value what is,
only what is NOT!
If you call yourself
an artist and your
medium is oil on canvas,
you're either / dishonest,
or you're a
FUCKING
MORON

SIX POINT

(Jesus handing Judas
a piece of bread
in 6-point perspective)

By Aaron Heideman

The Last Supper

IMPROV. & STRUCTURE
Alpha & Omega
Circle → Cycle

Oct 28th
SEATTLE, WA

one side
of 3D
Dodecahedron

Dodecahedron
Universal...
Catholic...
Cathode
Ligh

Eyeball

6-point perspective

Target

Triangle

Pisces

Butterfly

6-point perspective (birds eye)

one cell multiplying

Fire

FAITH FLOW

One cell Divided into two Equals JESUS

Cube = Earth
Earth = 6-point perspective

Life did not start with the Big Bang! The universe wraps around

THIS IS UNITY
THIS IS FREEDOM
THIS IS LIFE

One through Five POINT

6-point perspective

Manifestation

More

The Golden ratio creates a straight line around a sphere sphere !!!

a Globe of Time & Expands & contracts with each Big

2004
Heideman

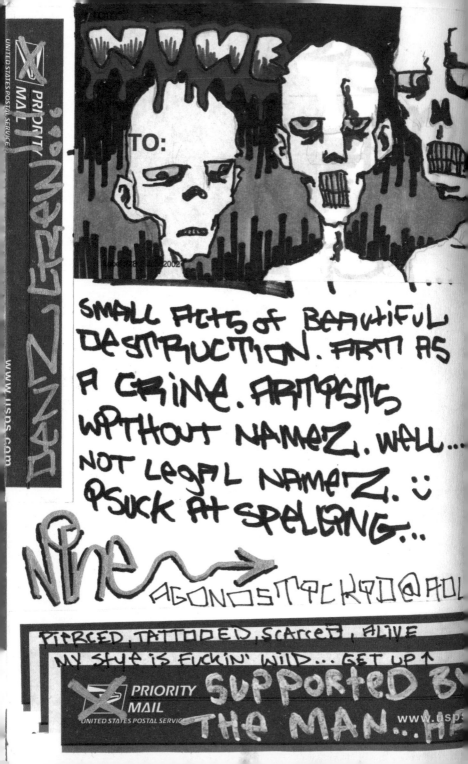

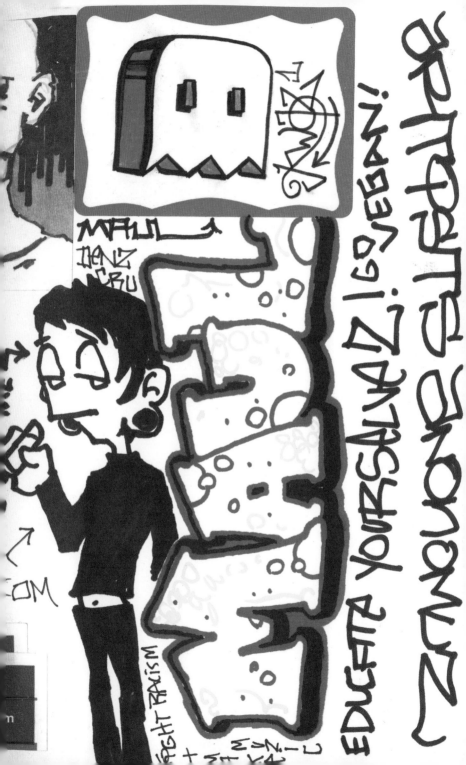

modogliani Quiller 6/1/04

modogliani

BTully
u1

I CAN HOLD THE MOON IN MY HAND.

BUT I'M ALWAYS SCARED I'LL DROP IT

"I'M CAPABLE OF MORE. I DON'T EVEN THINK WHAT I DO IS MY BEST."

life's a picnic

Bitter Optimist

GET THE FEELING

"Confidence is the sexiest thing a woman can have. It's much sexier than any body part."

"...What the #$@! was that!!?..."

Collectively, Americans spend about 9 million hours a day looking for misplaced items

REAM OF NSCIOUSNESS.

SHE KNOW WHAT YOU

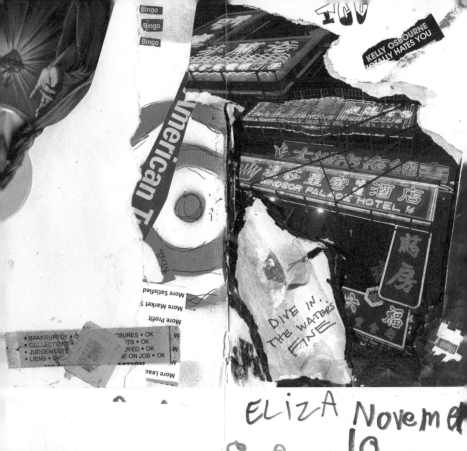

American T

WINDSOR PALACE HOTEL

大

DIVE IN..
THE WATER'S
FINE

More Satisfied

More Market s

More Profit

• BANKRUPTCY •
• COLLECTIONS •
• JUDGEMENT •
• LIENS •
OSURES • OK
TS • OK
YED • OK
ON JOB • ON • OK

More Lea

Bingo

ELIZA Novemb
18 Cool
I N gal LOVE
you
TONite
I Had my
First Clas-
SICAI CONS-
Rt.

I want to blow up buildings Burn trs and poison the Rich.
I want to piss on the Constitution.
Don't you? (not even a little bit?)

WHY live FOR TO day
WHen TOMARR OW
HOlDS so much potential ...

Because TODAY IS TOMARROW!

This is Your liFE, Good TO the last Drop

home: 12:00AM 2AM diligent (sp?)

A little about my self

I am 16, born April 14 1984, going
on 17 in 3s something days.
I live in weatherford oklahoma w/
my Biological parents and one brother
diagnosed w/ severe ADHD/ADD.
I Am Neurotic. Neurotic as all hell.
My biggest Phobic is Death 2 used
to know the technical term for
that Phobia. I'm in way college
Psychology class. I am a sophmore
An alcholic and Drug addict of
Barbituits and, coke NOT REALLY and my Brother
Amphetimiens (For his aDD).
I love pot but it usually just Gives
Me anxiety over being caught.
I am Drunker than 2 thought
Right now. My scalp is
Yummy. I know 2 have a
Drought some where in this Room

Talking shit about a
Pretty snnat.

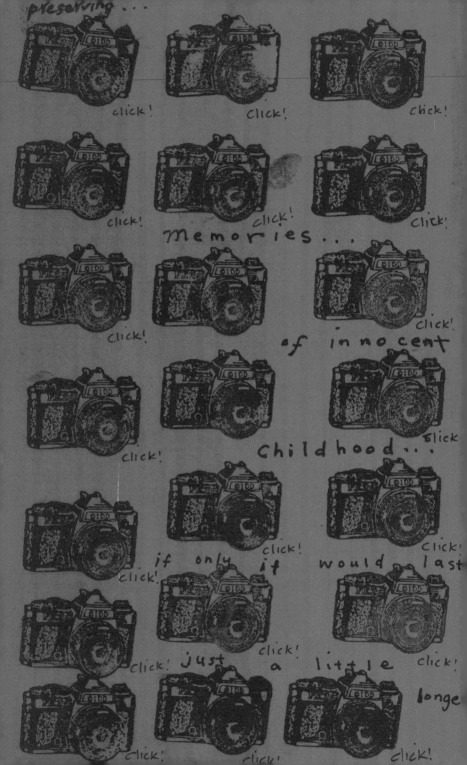

preserving...

click! Click! Click!

click! click! Click!

memories...

Click! click! Click!

of innocent

click! slick

childhood...

click! click!

if only it would last

click!

just a little click!

longe

click! click! click!

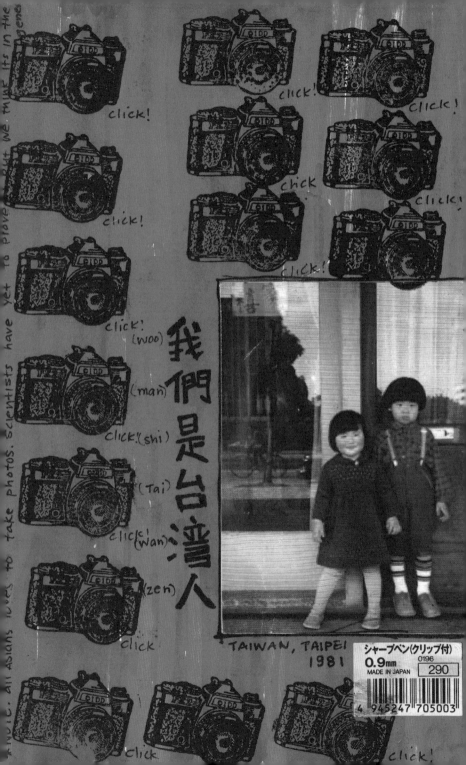

Journal 786

Brooklyn, New York
I received the journal just before departing to the Tibetan parts of
Qinghai, China. Kept it for the two days of plane/train travel and
finally added to it in a little village called Yushu. I gave the journal to
a nice French backpacker girl named Selinde who was headed for
Xiahe via Tongren. She said she would pass it on ... and upon returning
home to L.A. this morning I found a postcard from her that said she
gave it to a German.

Tokyo, Japan
The journal came to me somewhat magically in the Kinokuniya
bookstore in the Akihabara district of Tokyo on March 30th. I was
reading a magazine called *Brutus Casa* when a young Japanese girl
gave it to me. She said her name was Tomoko, but otherwise offered
little information. After I took it, she bowed and scurried off.

On April 2nd, I flew back to the U.S., where I passed through Los
Angeles. Being curious, I delivered the journal in person to the
address in North Hollywood listed on the first page. Nobody was
home so I left it on the doorstep.

North Hollywood, California
I came home and it was on my doorstep. No signs of any postage or
handling, just like someone came by and dropped it off. It took me a
day or so to figure out what to contribute ("24 hours"?) but the next
night, at a party, I had a dozen or so of my friends write down three
words, their message to the world. I thought it was a pretty clever idea,
but it didn't turn out well.

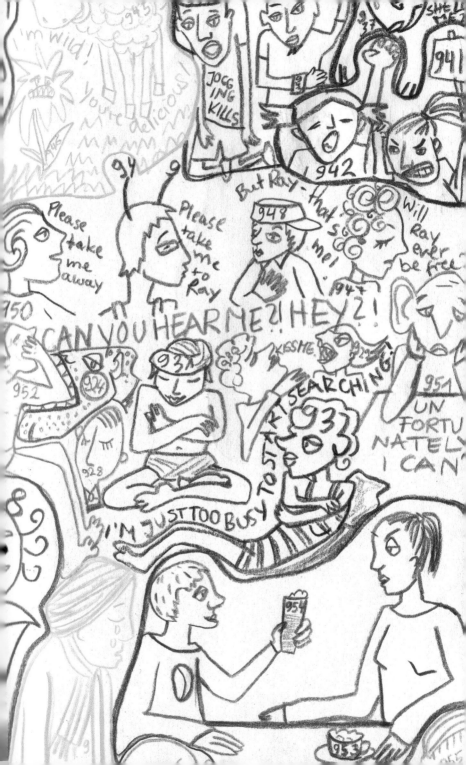

I WAS 4 HOURS INTO THE WORKDAY TODAY, STANDING IN ONE OF A HUNDRED COURTYARD VIEW OFFICES IN THE LONGEST BUILDING IN THE WORLD, WHEN I REALIZED I WAS WEARING TWO DIFFERENT SHOES. IT WASN'T UNTIL I SAW THEM THAT I REALIZED ONE WAS TIGHTER WITH A THICKER SOLE. IT SUDDENLY SEEMED AWKWARD TO STAND OR WALK, THOUGH I HADN'T NOTICED IT ALL MORNING. AND IN SPITE OF THE SUDDEN STRANGENESS, DROPPING OUT OF THE CONVERSATION, STARING AT MY FEET, I SMILED AND COULDN'T STOP. IT SEEMED SIGNIFICANT TO ME. PORTENTOUS, MAYBE. OR MAYBE NOT. BUT IT SEEMED TO ME, WITHOUT A DOUBT, TO BE HOPEFUL. I FELT GOOD, THANKS TO MY MISMATCHED SHOES. I FELT LIKE I HAD JUST BEEN SENT A MESSAGE.

MOST OF THE TIME IT SEEMS LIKE THE WORLD IS INCAPABLE OF SURPRISING US. AND MOST OF THE TIME I THINK THAT I AM INCAPABLE OF SURPRISING MYSELF.

IT'S SELF-PRESERVATION AS MUCH AS IT IS LAZINESS. WE WANT TO THINK OF THE WORLD AS FIXED AND MANAGEABLE. WE WANT TO THINK OF OURSELVES AS THE STABLE CENTERS OF OUR RESPECTIVE GALAXIES. SURPRISES ARE RISKY. NOT KNOWING YOURSELF IS DANGEROUS, EVEN IF "KNOWING YOURSELF" MEANS PIGEONHOLING AND STEREOTYPING YOUR OWN ACTIONS, IT'S BETTER THAN THIS FLOWERCHILD INSTABILITY OF NOT KNOWING WHO YOU ARE.

SOMETIMES WHO WE ARE WANTS TO ANSWER BACK, WANTS TO EXPRESS PERSONALITY IN SPITE OF OUR EFFORTS TO CONTROL IT. I SENT MYSELF A MESSAGE IN A BOTTLE THIS MORNING WHEN I DIDN'T PAY ANY ATTENTION TO MY SHOES AS I PUT THEM ON. I BUILT A REMINDER INTO THE LATER, MORE CONTROLLED PART OF THE DAY:

TODAY IS NOT YESTERDAY, AND IT'S CERTAINLY NOT TOMORROW. THOSE PEOPLE ON THE BUS HAVE DIFFERENT THOUGHTS, YOU DON'T HAVE TO WALK THE SAME PATH AS ALWAYS, YOU ARE NOT IN CONTROL.

Makes
sound

mentalmeat
@hotmail.com

BENJAMIN ARMSTRONG

№ 613 6456

...e offices o...
... have remobilized and
set-u... base within the
files. ...Please update your
... information again or
formally notify any other
personnel. If your office
should require any new
information about
... ask you to report
in confidentiality.

Internal Memorandum RE: 218

BENJAMIN

BENJAMIN ARMSTR...

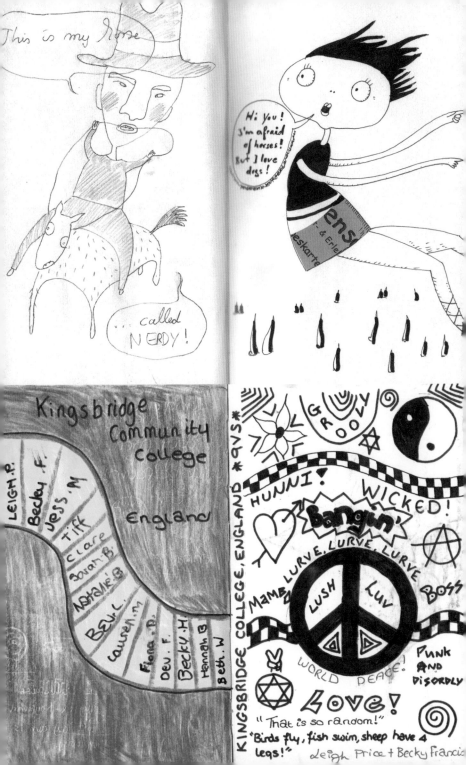

ACROBAT

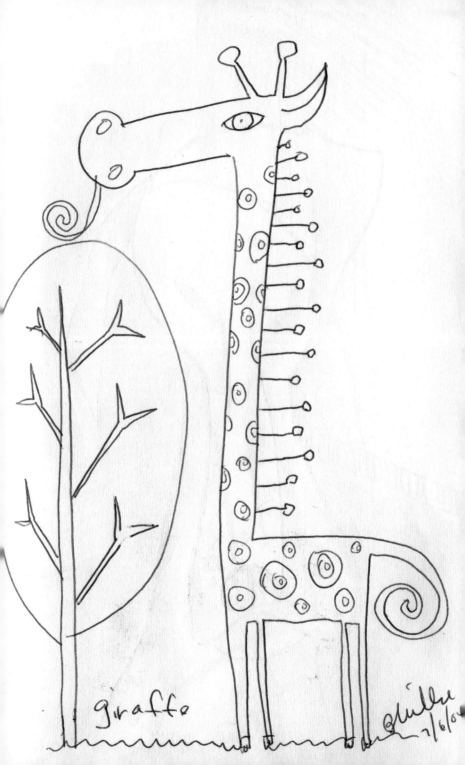

giraffe

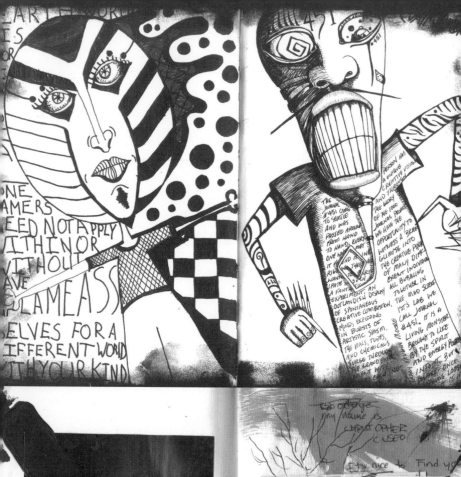

EARTH WORLD
ES
OR

ONE
AMERS
EED NOT APPLY
ITHIN OR
ITHOUT
AVE
LAMEASS
ELVES FOR A
IFFERENT WORLD
TH YOUR KIND

THE
JOURNAL
#451 CAME
TO SEATTLE
AND WAS
PASSED AROUND
FROM HAND
TO HAND. EVERY
ONE WHO PAGES
IT FIND IT
RIGHT THERE
WANT TO CREATE
A FANTASTIC
PATE TO PARTICIPATE
EXPERIMENT. AN
OUTLANDISH DISPLAY
OF SPONTANEOUS
CREATIVE COMBUSTION,
MINDS EXPLODING
IN BURSTS OF
ARTISTIC SPASM,
THE VIALS, TUBES,
AND CHEMICALS
SURGE THROUGH
THE BRAND EXIT
OUT WITH

PERSON HAS
A UNIQUE
CREATIVE VISION
AND THE STORY
THE STORY
OF THE 1000
JOURNAL PROJECT.
WE HAVE THE
OPPORTUNITY TO
WITNESS A BRIEF
GLIMPSE INTO
THE CREATIVE PROCESS
OF MANY DIFFERENT
EVENT INDIVIDUAL
ALL BUBBLING
TOGETHER IN
THE MAD SLIDE
IST'S LAB WE
CALL JOURNAL
#451. IT IS A
LIVING MONSTER
BROUGHT TO LIFE
BY THE SPIRIT
AND ENERGY

I WILL REMEMBER
the DAMAGE

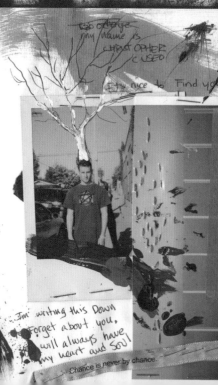

my Name is
CHRISTOPHER
CUSEO!

nice to Find yo

I'm writing this Down
Forget about you,
will always have
my heart and Soul!

Chance is never by chance.

Journal 323

I left the journal on the top of a Croatian mountain (Tuhobic) on July 30th. I hope that someone who cares will find it…

Update:

I visited Tuhobic exactly one year later. The journal was still there. Mountaineers were using it as a sign-in book. So I took it with me and now it is somewhere in Zagreb.

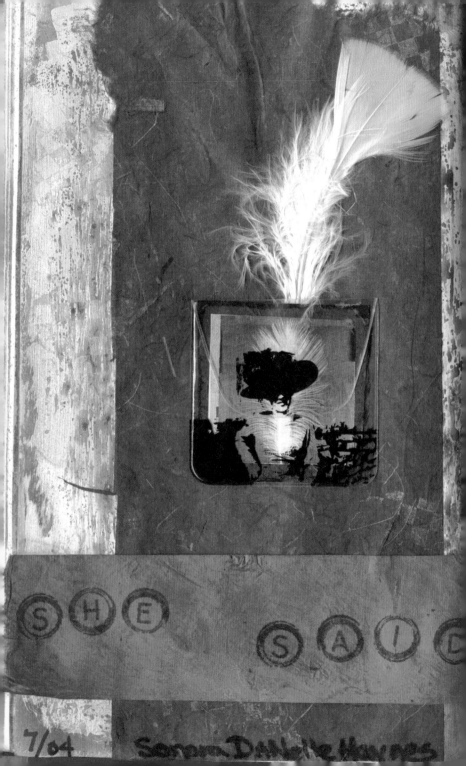

SHE SAID

7/04 Sonora Danielle Haynes

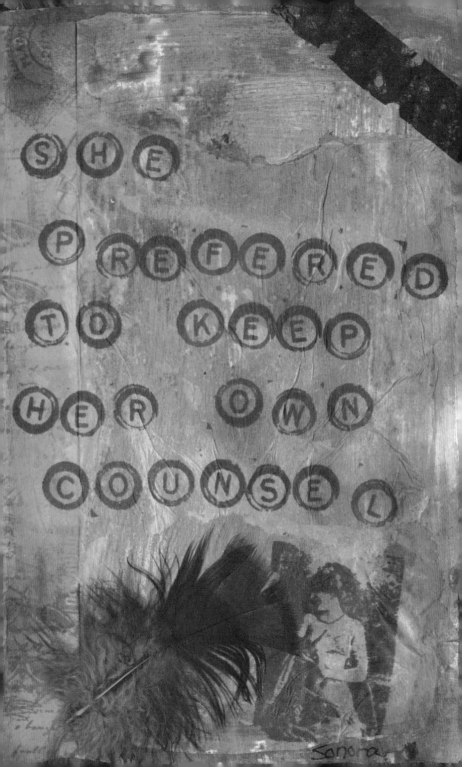

I leave my thoughts as half scribbled words and sentence fragments on paper because they are not yet complete inside my head. I read them later in hours of lonliness and I piece together the full emotion. What I hope others will be able to piece together. I write because I secretly want some one to read.

(A piece from _my_ journal dated 2/20/03.)

A story

Once when I was young I got lost in home Depot ... how I got lost; I had this facination with the kitchen set ups ... I used to wander through them on our quite frequent spring depo trips and picture my future kitchen. I was fond of bread cabnits. On this particular trip I Greuss my parents didn't notice me wander into my maze of samples ... When I Realized I was "lost" I was expecting a wave of panic ... I don't think it ever came. I sat on one of those big orange pallattes they use for lumber carts, chin in hands starring at the endlessly tall shelfs and spinning cielling fans. a feeling of spontinaty and freed our came over me, with out my parents

take me home there were a million possibilities open to me. I was overwhelmed but relaxed... it was wild and bizzarre but it comforted me. I was ready to be kid-napped.

send a letter
get a letter
R + 3 Box 214
WEATHERFORD OK

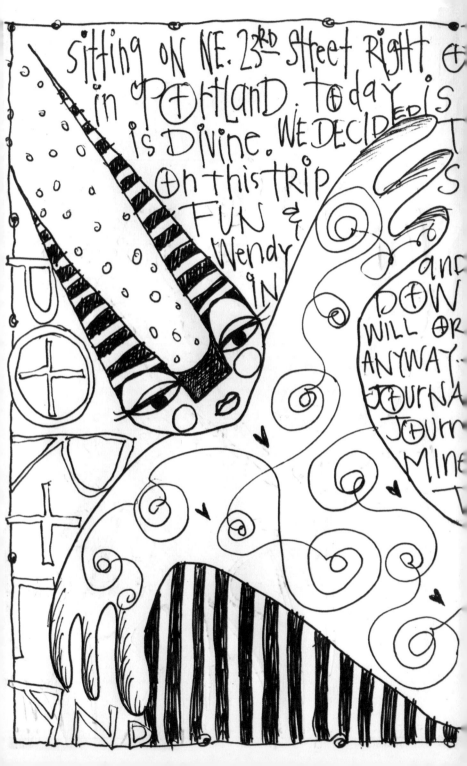

t in front of Vivace coffee & Crepes
September 3, 2004 & the weather
t stay @ INN @ Northrup Station
nce it is walking distance to
coffeehouses. Last night we met
Kat for some red trout @ Jakes
ntown. I'm crazy for trout, &
der anytime it's on the menu.
normally I wouldn't be
-ing in someone else's
al but I didn't bring
this morning so
racy said "here."

Portland is tattoo Land

Journal Cover Designs

a.

b.

c.

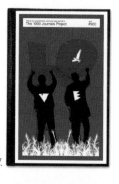

d.

e.

f.

g.

h.

i.

Geoff Ahmann
akacreativegroup.com
Palo Alto, CA, USA

Mark Arminski
arminski.com
Royal Oak, MI, USA

j. Michael Bartalos
bartalos.com
San Francisco, CA, USA

k. Gary Baseman
baseman.com
Los Angeles, CA, USA

Briana Bolger
monkeypile.com
Chicago, IL, USA

o. Stephan Britt
sbritt.com
Sacramento, CA, USA

i. Thomas Brodahl
surfstation.lu
Mamer, Luxembourg

Mike Cina
weworkforthem.com
youworkforthem.com
Roseville, MN, USA

Joshua Davis
joshuadavis.com
Mineola, NY, USA

Gregory Durrell
xrtions.com
Ontario, Canada

Vanessa Enriquez
Brooklyn, NY, USA

e. Amy Franceschini
futurefarmers.com
San Francisco, CA, USA

m. Craig Frazier
craigfrazier.com
Mill Valley, CA, USA

Jemma Hostetler
(née Gura)
jemmahostetler.com
prate.com
NYC/Toledo, NY, USA

John Hersey
hersey.com
San Anselmo, CA, USA

Anders Hornstrup
stuka.dk
Copenhagen, Denmark

d. Cody Hudson
struggleinc.com
Chicago, IL, USA

Andrew Johnstone
designiskinky.com
Coogee, NSW, Australia

Hitomi Kimura
Saitama, Japan

Shirin Kouladjie
photomontage.com
Seattle, WA, USA

Luc Latulippe
luclatulippe.com
Vancouver, BC, Canada

p. Simone Legno
tokidoki.com
Los Angeles, CA, USA

n. Michael Mabry
michaelmabry.com
Emeryville, CA, USA

Richard May
richard-may.com
London, UK

Tim McLaughlin
box19.ca/tmcl
Grantham's Landing,
BC, Canada

Craig Metzger
enginesystem.com
Los Angeles, CA, USA

Moderndog
moderndog.com
Seattle, WA, USA

Jason Munn
thesmallstakes.com
Oakland, CA, USA

Christopher Pacetti
P2Output.com
San Francisco, CA, USA

Simon Powell
flameproof.org.uk
London, UK

Christopher Robbins
designhistoryinabox.net
London, UK

c. Claire Robertson
loobylu.com
Blackburn South,
Australia

Journal cover designs were
contributed by well-known
and emerging artists from
around the world. Each
cover is used on ten of the
journals, for a total of one
hundred unique designs.
To view all the covers, visit
1000journals.com.

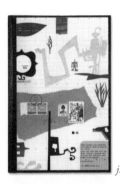

j.

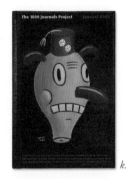

k.

l.

m.

n.

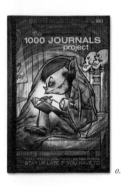

o.

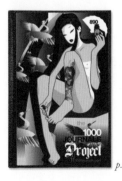

p.

q.

r.

Acknowledgments

To the thousands of people who poured their hearts and souls into the journals, and those still to come, this project is nothing without you. Thank you.

I'd also like to thank the following people: My family, who has supported me in all of my endeavors, even the misguided ones. Joshua Swanbeck, for sneaking me into his office on the weekend to print out that first batch of journal covers. Nate Koechley and Erik Benson, for helping to create the Web presence, and Charles Mastin, for his hard work on the next generation of the project, 1001journals.com. Andrea Kreuzhage for believing in the project, and taking it to places I'd never imagined possible. Each and every one of the cover designers, who selflessly gave their time and energy to the project. Ruth Keffer, for her continued support and advice. Matt Thompson, for his command of the English language. Fred Gray, for helping out in tracking down journal contributors. Hollie Rose, for returning the first journal, #526. Diane Reese, Michaela Darling, and the other wonderful ladies for returning the second journal, #550. Leslie Jonath, Kevin Toyama, Brooke Johnson, Doug Ogan, Evan Hulka, Yolanda Accinelli, and everyone else at Chronicle Books, for making this book on the craziest schedule ever. Everyone who emailed me with kind words and support—you kept me going through the rough times. My friends (you know who you are), for your friendship and support over the years. Finally, to everyone who's ever kept a diary, journal, or sketchbook, or just likes to doodle during company meetings, thank you for keeping creativity alive.

884
unknown
(cover detail)

890
Simone Legano
tokidoki.it

649
unknown

801
unknown

664
Juliana Coles
meandpete.com

664
Juliana Coles
meandpete.com

610
Melissa McCobb Hubbell
magikglasses.com

550
Diane Reese
mootmom.editthispage
.com

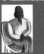

884
unknown

311
Eva Jaeger
tatendrang-design.de

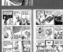

311
unknown

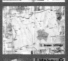

751
Kris Henderson
studiohen.com

960
Richard Pasqua, 2003
rich@errortype.com

685
unknown

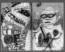

829
Ryan Junell
junell.net

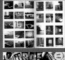

890
Tanya Zani
tanyazani.com

526
Matvei Yankelevich

915
Cheryll Del Rosario

784
Andrew Trague

912
Lindsay Shutt

884
Mari

707
Deborah Weber

988
Pamela Joutras

987
Hanna-Reeta Koivaara

610
Julie Sadler
magikglasses.com

311
Meike Töpperwien
tatendrang-design.de

451
Tracy V. Moore
zettiology.com

930
Witold Riedel
witoldriedel.com

900
Lori Seidemann

987
Hanna-Reeta Koivaara

751
Kris Henderson
studiohen.com

915
Megan Mock
m-mock.com

664
Valerie Roybal
valerieroybal.com

610
Aisling D'Art
aisling.net

988
Keith Walbrun
monsieurdesign.com

784
Andrew Trague

884
unknown

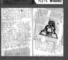

707
Leslie Dinaberg
lesliedinaberg.com

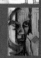

979
Erin Elizabeth Partridge

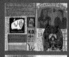

930
Kepi, Groovie Ghoulies
gogreendoor.com

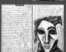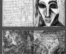

995
unknown

960
unknown

438
Giovanni F. Cappelletti
giocapp.com

953
Tanya Sprowl,
Jeremy Reid

767
Michael R. Bristow

960
Linda Zacks
extra-oomph.com

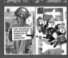

311
Chris Horstmann
chrishorstmann.de

986
Christopher Palazzo

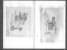

916
Mark Penta
markpenta.com

854
George

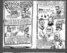

648
Michele Romero

664
Juliana Coles
meandpete.com

649
Theresia Koppers

967
Neosho - Box 08262
Chicago, IL 60608

526
unknown

896
Shinta Handamari
littlemissshinta@
hotmail.com

610
Melissa McCobb Hubbell

960
Linda Zacks
extra-oomph.com

915
Suzanne Norris
suzannenorris.com

925
Erin Elizabeth Partridge

757
Kristen Fournier

451
unknown

172
Sean Clinton,
Angel Villanueva

987
Sylvie Lannes

960
Linda Zacks
extra-oomph.com

979
Jeff Chang

912
Zoe

526
Tony Palmieri

664
Valerie Roybal
valerieroybal.com

979
Erin Elizabeth Partridge

915
Amie I. Lin
amielin.com

987
Laura Coulter

890
Manuel Tan
uncontrol.com

953
Tanya Sprowl, Don
Smith, Jeremy Reid

900
David Cuesta

967
Neosho - Box 08262
Chicago, IL 60608

925
Erika B.

896
Shinta Handamari
littlemissshinta@
hotmail.com

526
Hollie Rose,
Ashly

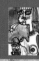
987
Claire Priestly

979
Erin Elizabeth Partridge

610
unknown

757
Rasha

801
Sarah Mark,
Jessica Eden

912
Zoe

664
Natalia Smirnov

801
Keith Walbrun
monsieurdesign.com

987
Tracy V. Moore
zettiology.com

872
Lisa

979
Erin Elizabeth Partridge

757
Joe Robitaille
ashberyband@hotmail.com

664
Valerie Roybal
valerieroybal.com

900
Lori Seidemann

987
Hanna-Reeta Koivaara

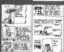
912
Scott Bateman
batemania.com

610
Julie Sadler
magikglasses.com

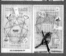
767
Michael R. Bristow

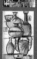
172
Sean Clinton

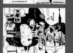
800
Juan Angel Chavez
mudstudios.com

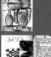
872
Cristiane Giamas

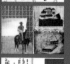
664
Valerie Roybal
valerieroybal.com

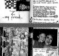
988
Pamela Joutras

801
Jessica Eden

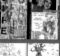
967
Phil Hill

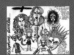
915
Suzanne Norris
suzannenorris.com

995
unknown

550
Phil Perkins

751
Cameron Okamoto
(a.k.a. Evan's Dad)

979
Claire Woods

648
Eliza Burr

967
unknown

995
unknown

616
Kevin Tam
disoriental.com

915
Amie I. Lin
amielin.com

960
Linda Zacks
extra-oomph.com

311
Eva Jaeger
tatendrang-design.de

896
Lindsay

884
unknown

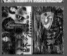
987
Tracy V. Moore
zettiology.com

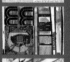
953
Benjamin Armstrong
benarmstrong@gmail.com

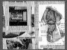
664
Valerie Roybal
valerieroybal.com

872
unknown

912
unknown

649
Theresia Koppers

536
Aaron Heideman

925
unknown

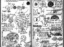
915
Daniel Tickner

912
Brian Willse
newbomb.com

912
Brian Willse
newbomb.com

451
Tracy V. Moore
zettiology.com

987
Christopher Cuseo

988
Sonora DaNelle Haynes

995
unknown

960
Linda Zacks
extra-oomph.com

536
Teesha Moore
teeshamoore.com

Due to the nature of the project, it's impossible to determine who contributed exactly what to each and every page. Many of the contributions are anonymous, or collaborations between several people. It is not my intent to highlight the work of any individual, but to showcase what we all created together.

That said, I also think it's important to give credit where credit is due. I made every effort to track down participants who contributed to the images included in this book and credit them properly. If you see an image of yours, and aren't credited, please contact me to be included in future printings of the book.

Visit the Web site at 1000journals.com for a more thorough record of the journals.

Someguy is the creator of the 1000 Journals Project, which he launched in August of 2000. People have speculated that he's actually a "she," or even a room full of monkeys with typewriters, but the truth is much less romantic. During the day, he dons his alternate identity as a graphic designer in San Francisco.

When he was ten years old, he accidentally killed a frog by dropping it into a coffee can filled with hot water.

His work has been recognized by AIGA: The Professional Association for Design, *Communication Arts*, *Graphis*, *Print*, *How*, and *Step*, among others. For the record, his head is not actually jellybean-shaped.

Kevin Kelly is Senior Maverick at *Wired* magazine. He helped launch *Wired* in 1993, and served as its Executive Editor until January 1999. He is currently editor and publisher of the Cool Tools Web site, which gets 1 million visitors per month. From 1984 to 1990 Kelly was publisher and editor of the *Whole Earth Review*, a journal of unorthodox technical news. He co-founded the ongoing Hackers' Conference, and was involved with the launch of the WELL, a pioneering online service started in 1985. He authored the best-selling *New Rules for the New Economy*, and the classic book on decentralized emergent systems, *Out of Control*.

PORTRAITS OF SOMEGUY AND KEVIN KELLY BY JOSHUA SWANBECK